God has inscribed Beauty upon all things.

KORAN

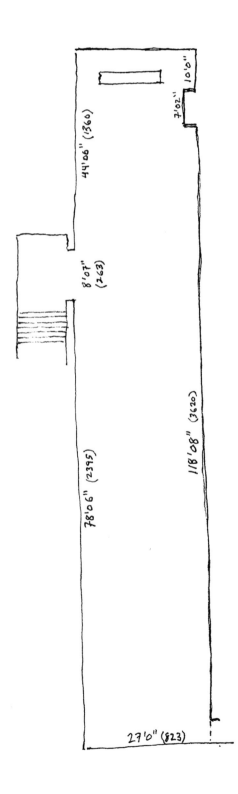

13 Jan, 1999

I want to create a space, an absolutely real, objective representation of the place where death is — or more, to make a work not about death but the place beyond death. This is the new landscape that needs to be represented. This is where I am in over my head.

The Sea · the swirling waters. Purple Black darkness
Churning, violent, seething, uncontrollable, threatening —
Sublime — viewing something harmful closely.

All walls, All surfaces are unstable and threatening.
From far, far away a voice is barely heard. A tiny figure
is seen in the waves, being tossed about like a paper doll.
He appears and disappears, part of the landscape, never quite
sure if he's coming back or gone forever. The viewer is helpless
to act . . . The roaring sound is deafening.

A total physical experience ___.

90° Shift in Orientation —

Large "sack" veiling ...

poss. horizontal projection of figure falling through layers of scrim cloth, or material surfaces

Tears and water . . .

 2 Spaces — contained/framed
 uncontrollable/frameless

When tears become a deluge.

Mater Dolorosa, Man of Sorrows

10 March Mater Dolorosa. Man of Sorrows.

An ocean of tears — weeping becomes the Sea.

Proposal 3/4/99

SUBJECT /OBJECT
OBJECT and REFLECTION
"An incessant River of life suggests a hidden,
inexhaustible Source." Coomaraswamy

The NIGHT SEA — Multiple projections fill all
wall surfaces with violent churning images of the
Sea. Dark purples, blues, blacks. Loud violent sound.
Unbearable intensity. Black on black — walls
 covered with panels of
 black scorched wood.

— The Wall of Pain

The Innocent Door

The HALL of SUFFERING —
quiet moments of pain and sorrow.
Groupings of human figures in action

Moving images panels on walls.
Controlled lighting. No sound.

ENTRY

RECEPTION

The innocent door separates the
world of external expression from the
direct experience of the Source of all
suffering.

The boatsman and crew are the only other people in the boat,
or there is an entourage accompanying him.
or man and woman are separated — she has already died. she
greets him on the shore and they leave together. Perhaps at
the opening of the scene there is a death bed sequence going on
in the house as the empty boat arrives with the old woman.

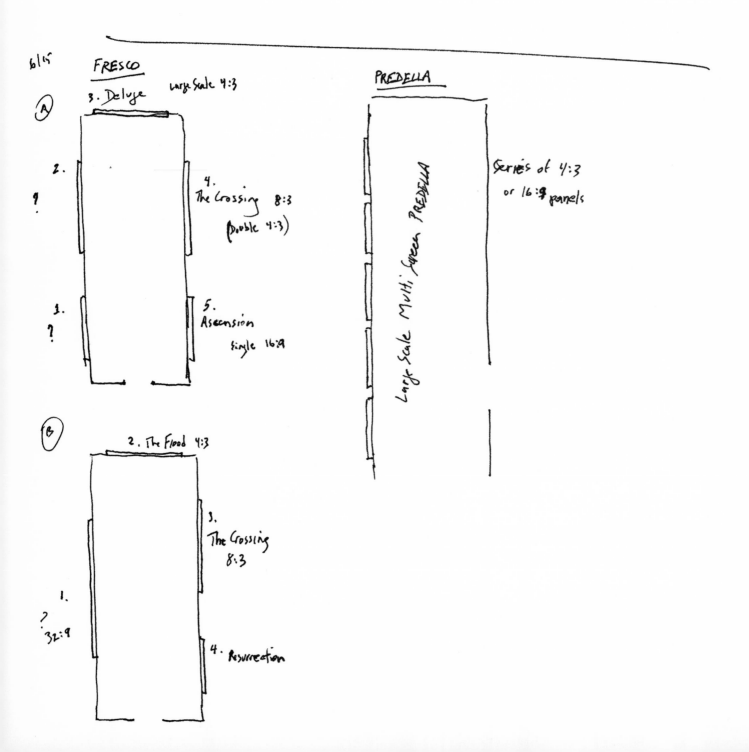

6/15

FRESCO

3. Deluge Large Scale 4:3

(A)

2.

9

4.
The Crossing 8:3
(Double 4:3)

3.
?

5.
Ascension

Single 16:9

(B)

2. The Flood 4:3

3.
The Crossing
8:3

1.
?
32:9

4. Resurrection

PREDELLA

Large Scale Multi-Screen PREDELLA

Series of 4:3
or 16:9 panels

Forest - A scene in a forest - Stylized: After
Botticelli's "Story of Nastasio degli Onesti" 1483

Vista - Hills of Tuscany - distant views of landscape,
like I witnessed from Orvieto on May 9 — to be used in
composite to create final

Create frame of house
and interior on site.
Match perspective lines of
room in studio with interior
of location, but build it in a
different scale, and/or position
it too close to the camera.

House extended too far forward.
Cut away scene of room interior with figure and
landscape outside. Interior is projected too far
forward towards Camera. Outside of structure and
interior walls were created on site to all lighting presence
and physical interaction by actors.

─────────────

Poss. Make all scenes be optical composites:
ie. shot on site and planned + calculated to fit together -
Shoot w/ different lenses (ie. boat w/ wide angle, house
with telephoto in the Salton Sea Master of Osservanza scene)

11 June

Can projection do what I want to do vis a vis detail and resolution?

Composite Painting: Can we take segments of scenes shot in different
places and stitch them together convincingly, or even coherently (even if defying the
laws of optical perspective)? What is the purpose of defying the laws of optical
perspective? Can I proceed intuitively (ie GREETING, CATHERINE) and create successful
alternative image spaces instead of embarking on a careful study to research a new system,
enlisting the help of young computer programmers. Uccello may hold the key...

GOING FORTH BY DAY

GOING FORTH
BY DAY

BILL VIOLA

BILL VIOLA

GOING FORTH BY DAY

GOING FORTH BY DAY

FIRE BIRTH

A human form emerges from a dim submerged world. The body swims in the fluid of an unconscious state between death and rebirth. Orange rays of light penetrate the surface of the water, coming from the previous world, which ended in fire. Now, illuminated by the light of prior destruction, the human essence searches for a way through this new underwater realm. It seeks the material form and substance necessary for its rebirth.

FIRE BIRTH

A human form emerges from a dim submerged world. The body swims in the fluid of an unconscious state between death and rebirth. Orange rays of light penetrate the surface of the water, coming from the previous world, which ended in fire. Now, illuminated by the light of prior destruction, the human essence searches for a way through this new underwater realm. It seeks the material form and substance necessary for its rebirth.

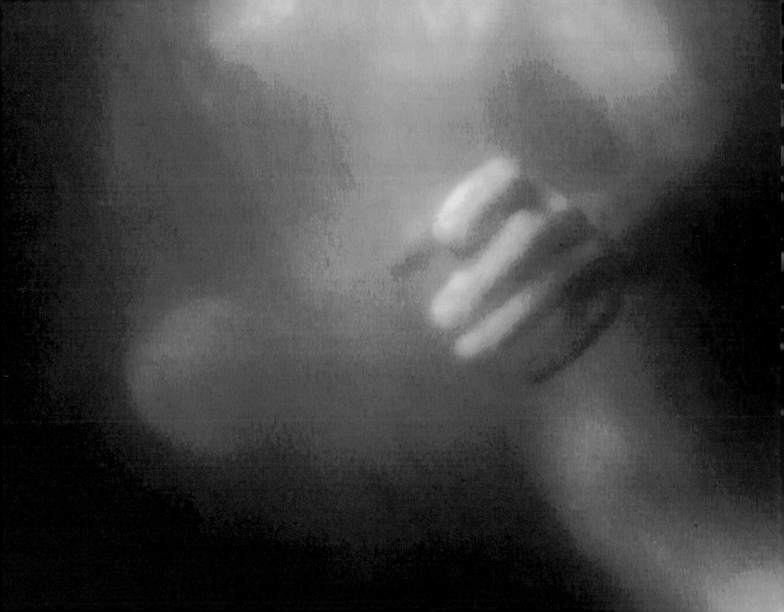

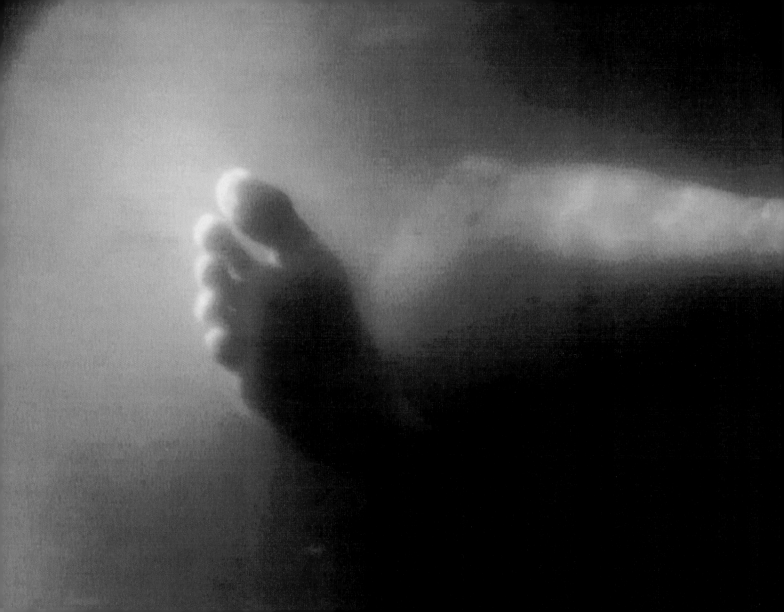

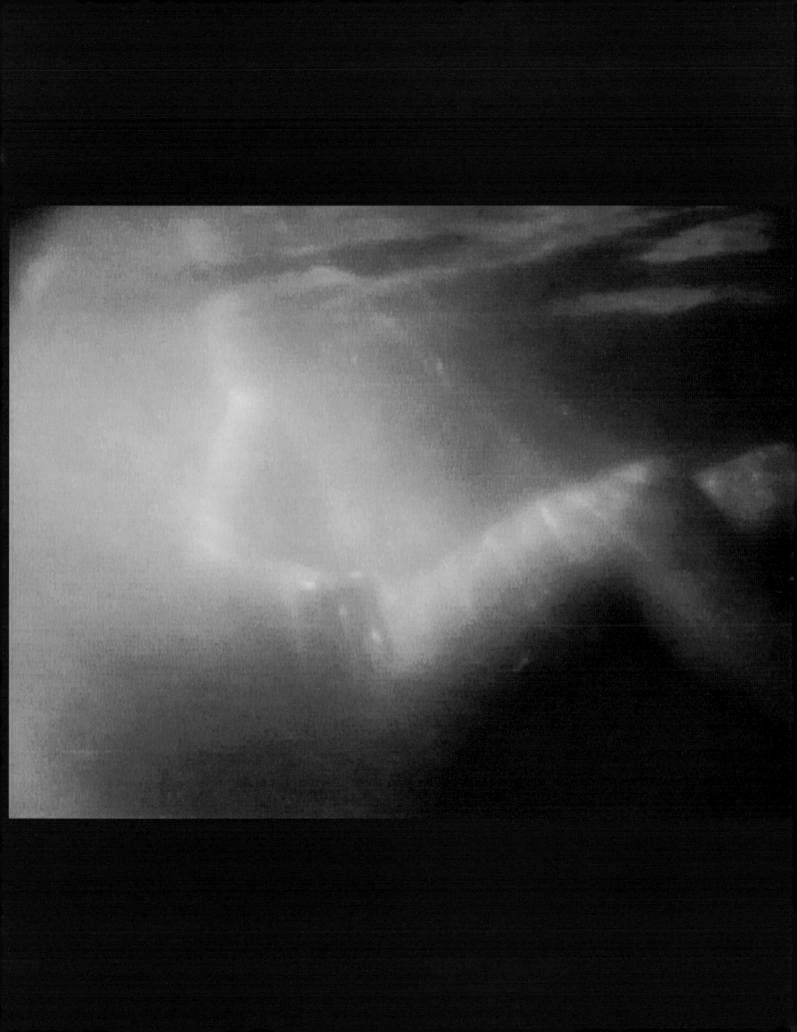

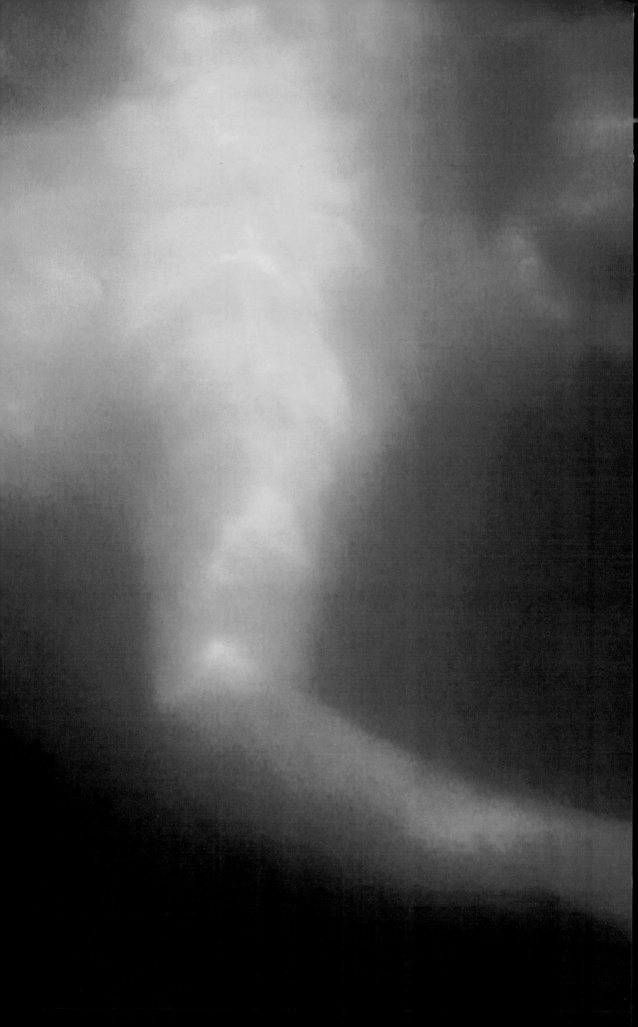

It is the time of the summer solstice high in the mountains. The early morning light reveals a steady stream of people moving along a path through the forest. They come from all walks of life, each traveling the path at their own pace in their own unique way. There is no beginning or end to the procession of individuals—they have been walking long before we see them here, and they will be walking long after they leave our view. The constant flow of people suggests no apparent order or sequence. As travelers on the road, they move in an intermediate space between two worlds. A small marker in the forest grants them safe passage through this vulnerable state.

THE PATH

It is the time of the summer solstice high in the mountains. The early morning light reveals a steady stream of people moving along a path through the forest. They come from all walks of life, each traveling the path at their own pace in their own unique way. There is no beginning or end to the procession of individuals—they have been walking long before we see them here, and they will be walking long after they leave our view. The constant flow of people suggests no apparent order or sequence. As travelers on the road, they move in an intermediate space between two worlds. A small marker in the forest grants them safe passage through this vulnerable state.

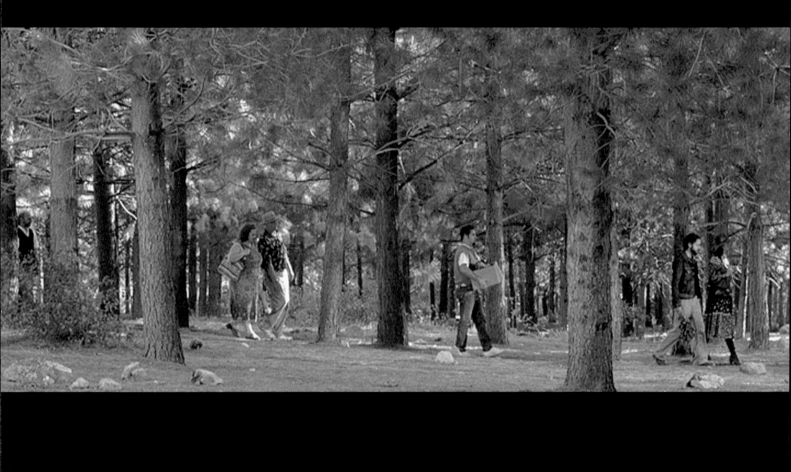

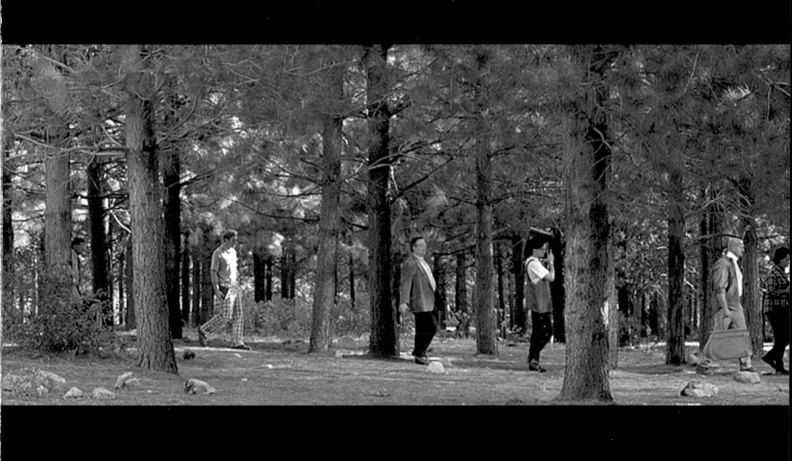

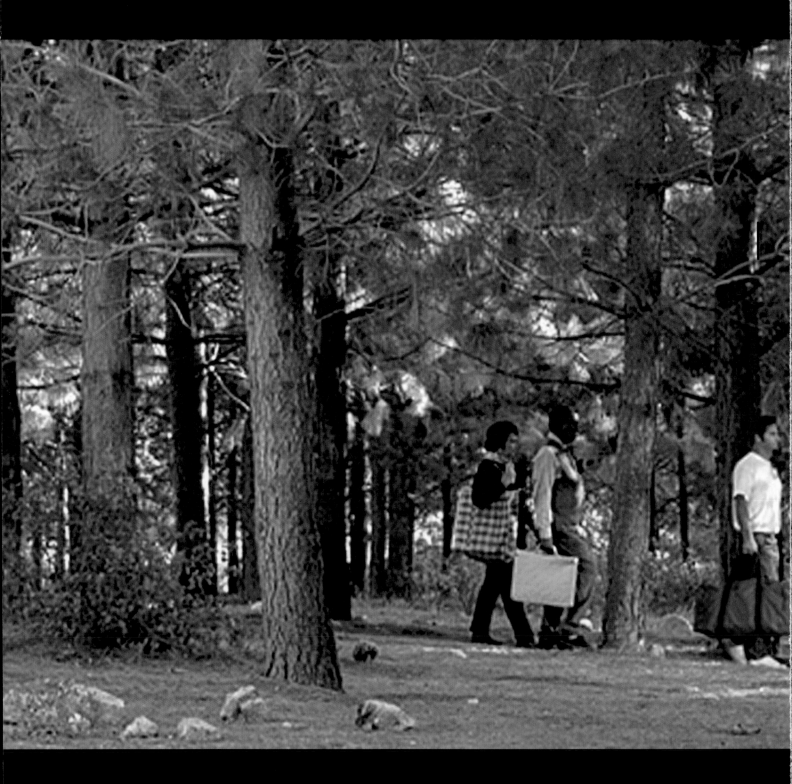

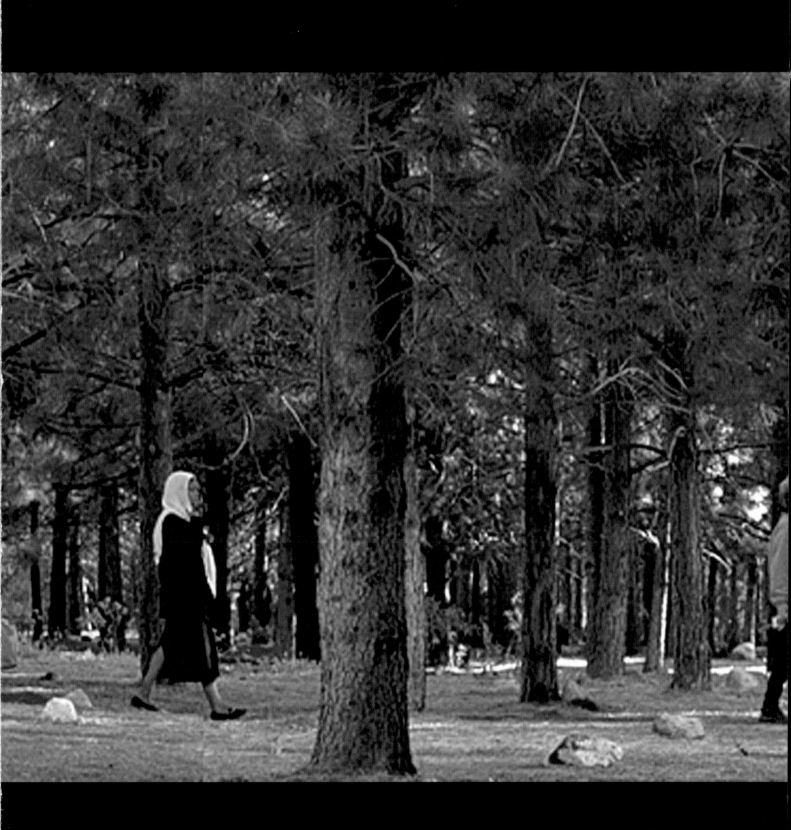

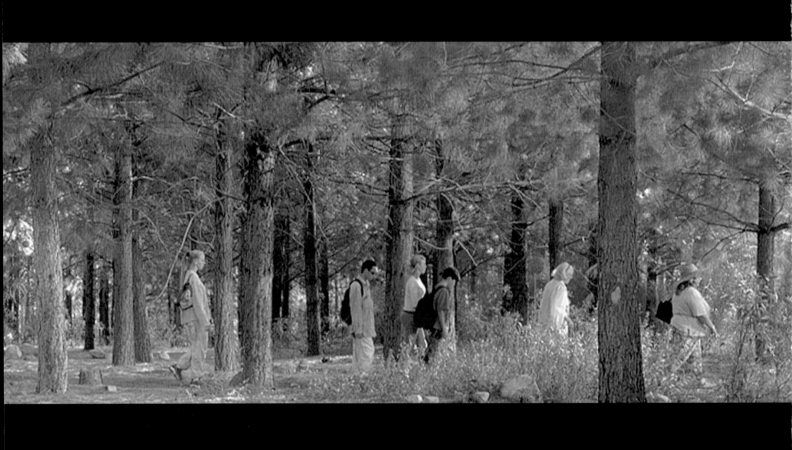

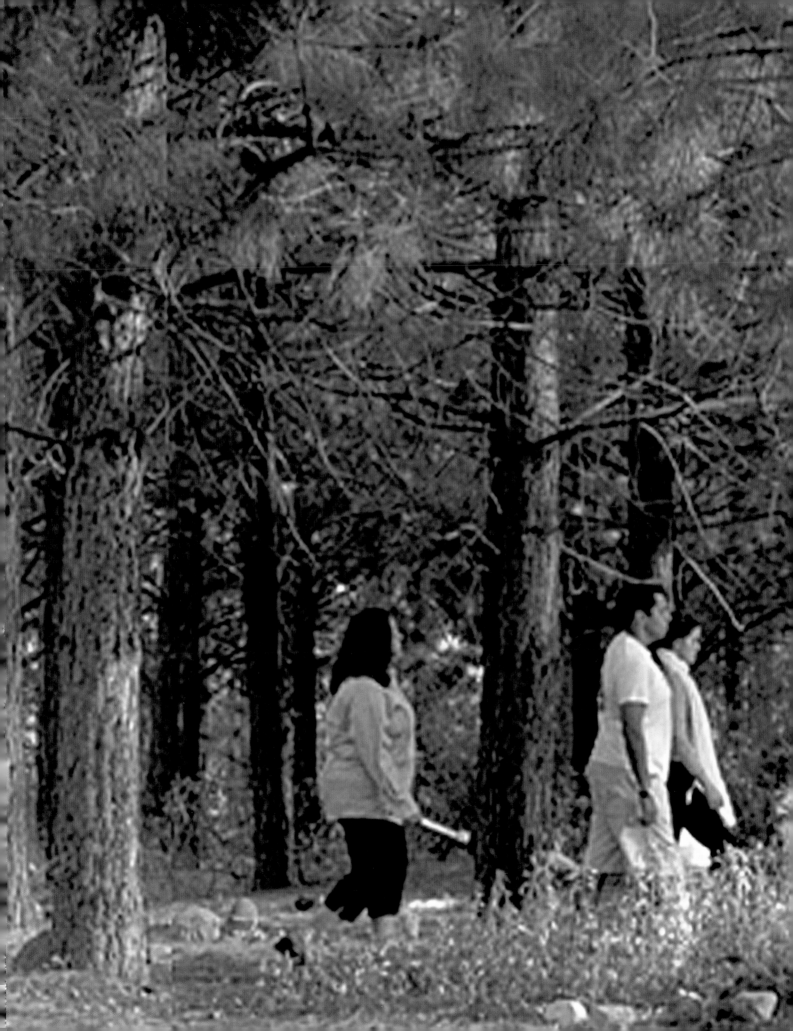

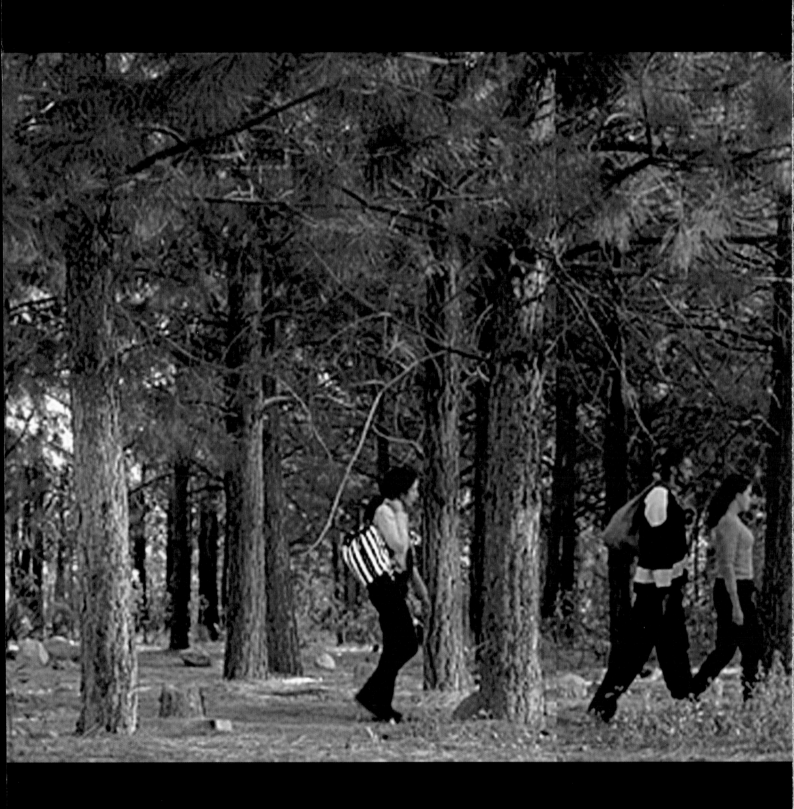

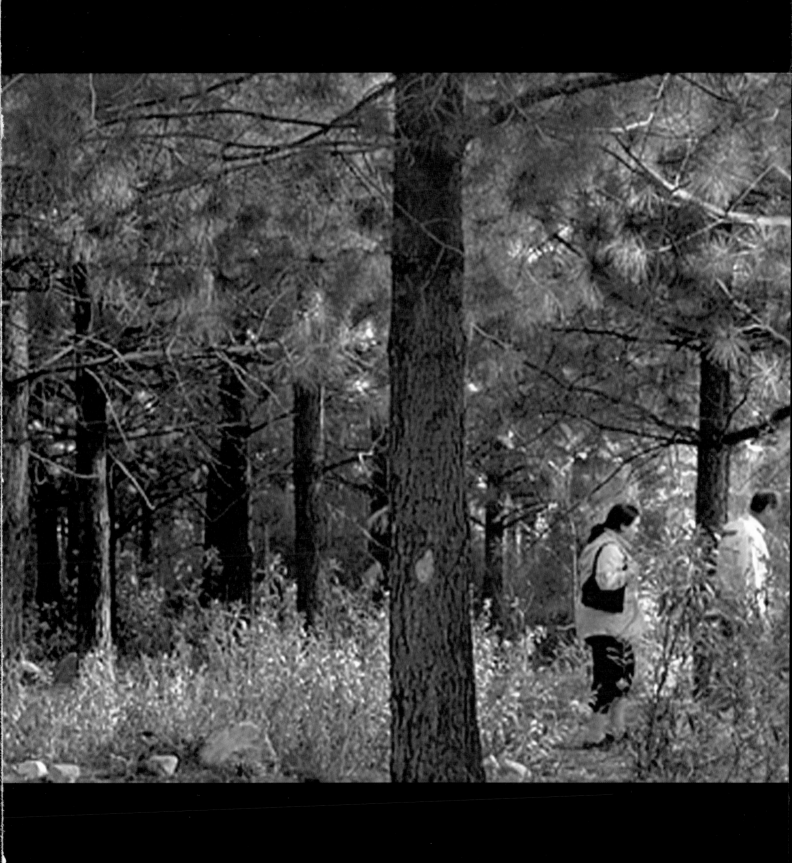

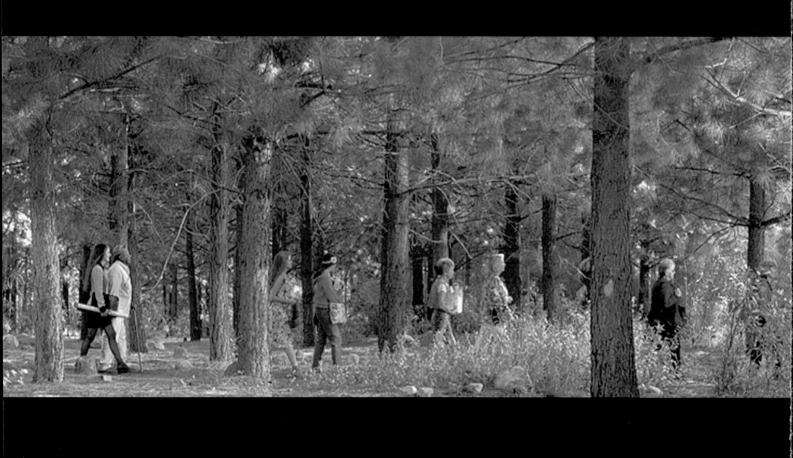

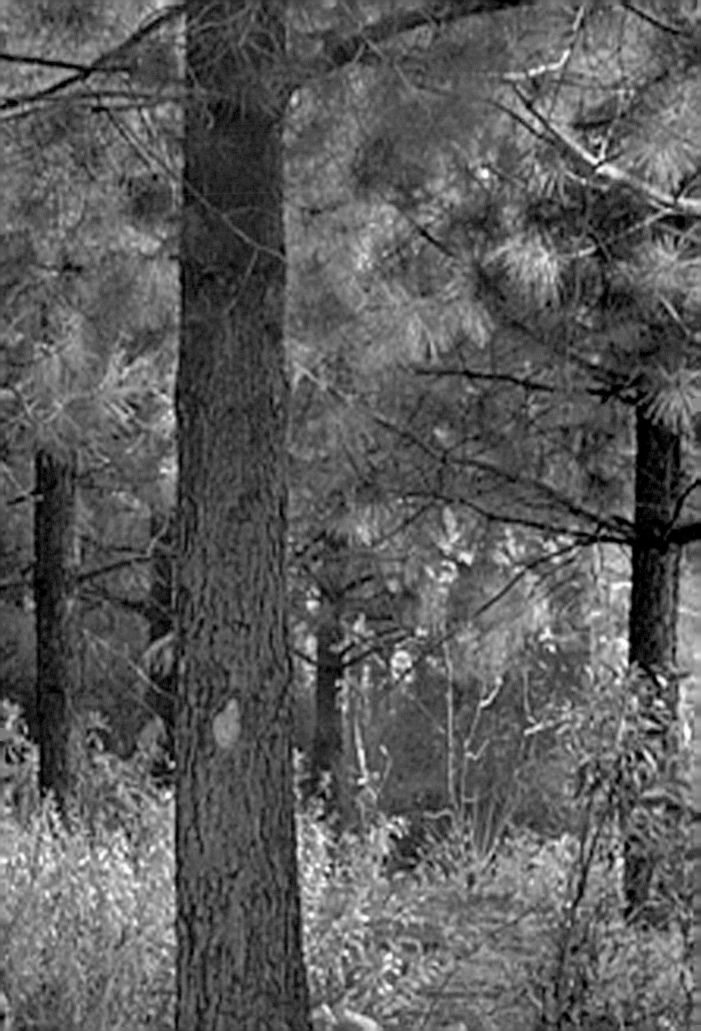

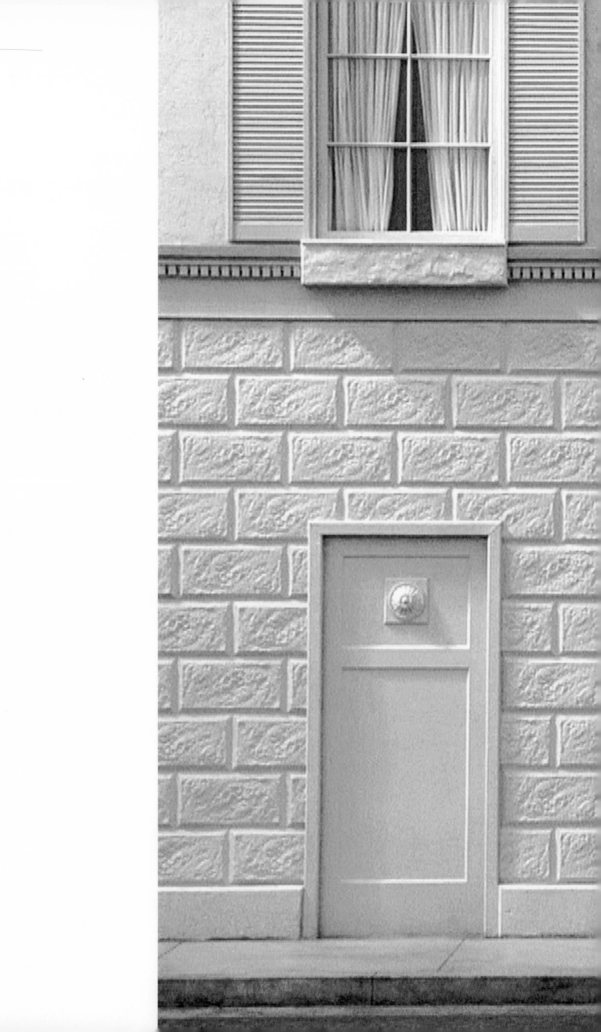

THE DELUGE

A stone building, newly restored, stands in the clear light of the autumnal equinox. People move along the street immersed in the flow of day-to-day events. Small incidents play out, affecting individual lives. Families are leaving their homes, people on the street are carrying personal possessions, and all actions become colored by an increasing tension in the community. Moments of compassion and kindness circulate within a mounting concern for individual survival.

A final moment of panic ensues as individuals rush to save themselves. The last ones, in denial of the inevitable, have waited too long in the security of their own homes. Now they must run for their lives as the deluge strikes with full force at the very heart of their private world. They rush out of the building when it is suddenly flooded from within by a raging torrent of water. Individual lives and personal possessions are arbitrarily chosen to be lost in the process. Finally, the violence and fury subside as the surging water slowly recedes, leaving the building unharmed and the street washed clean. The empty sidewalk glistens in the midday sun.

THE DELUGE

A stone building, newly restored, stands in the clear light of the autumnal equinox. People move along the street immersed in the flow of day-to-day events. Small incidents play out, affecting individual lives. Families are leaving their homes, people on the street are carrying personal possessions, and all actions become colored by an increasing tension in the community. Moments of compassion and kindness circulate within a mounting concern for individual survival.

A final moment of panic ensues as individuals rush to save themselves. The last ones, in denial of the inevitable, have waited too long in the security of their own homes. Now they must run for their lives as the deluge strikes with full force at the very heart of their private world. They rush out of the building when it is suddenly flooded from within by a raging torrent of water. Individual lives and personal possessions are arbitrarily chosen to be lost in the process. Finally, the violence and fury subside as the surging water slowly recedes, leaving the building unharmed and the street washed clean. The empty sidewalk glistens in the midday sun.

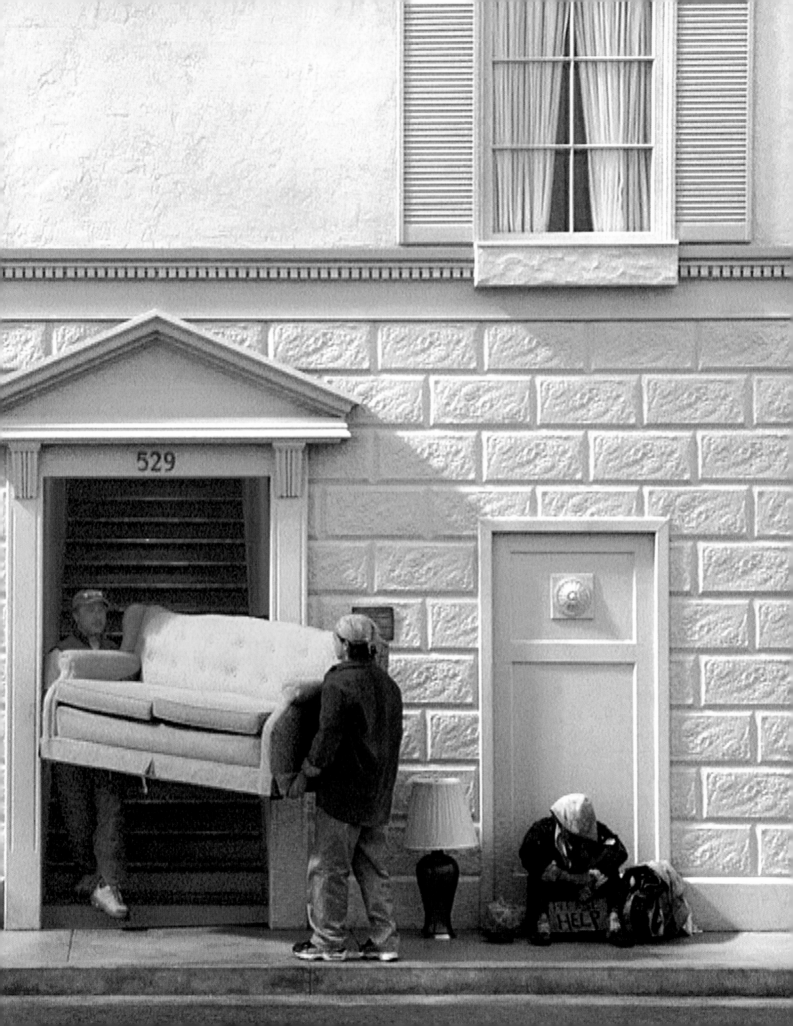

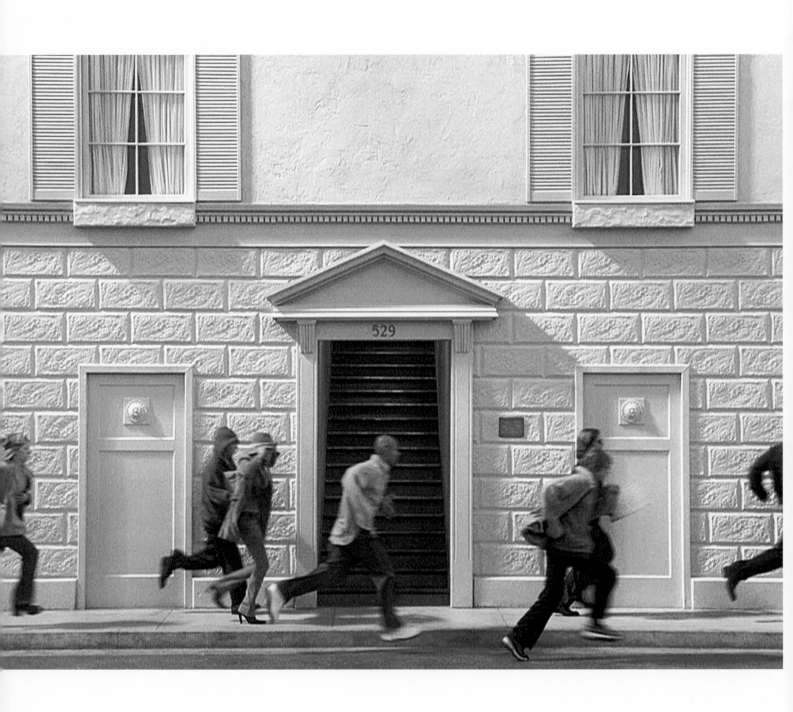

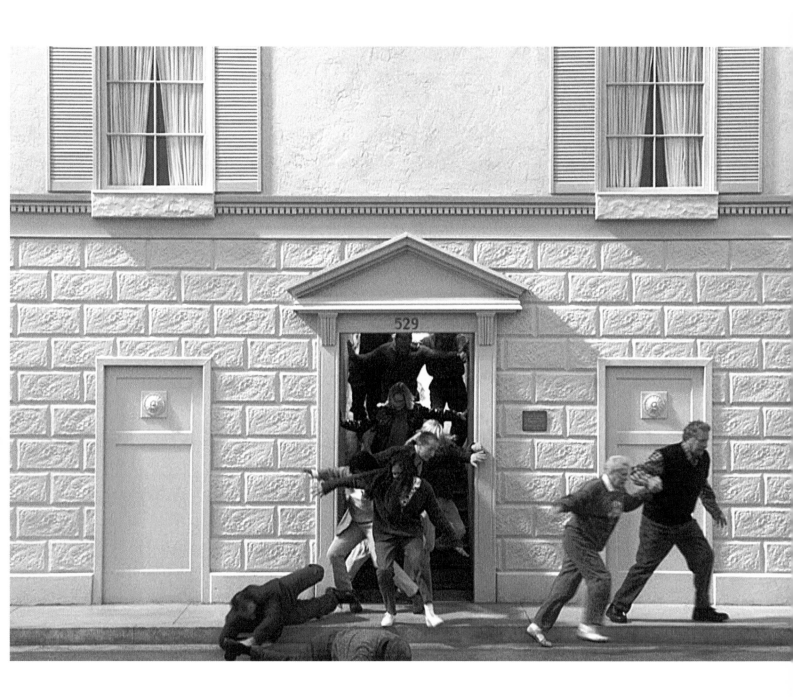

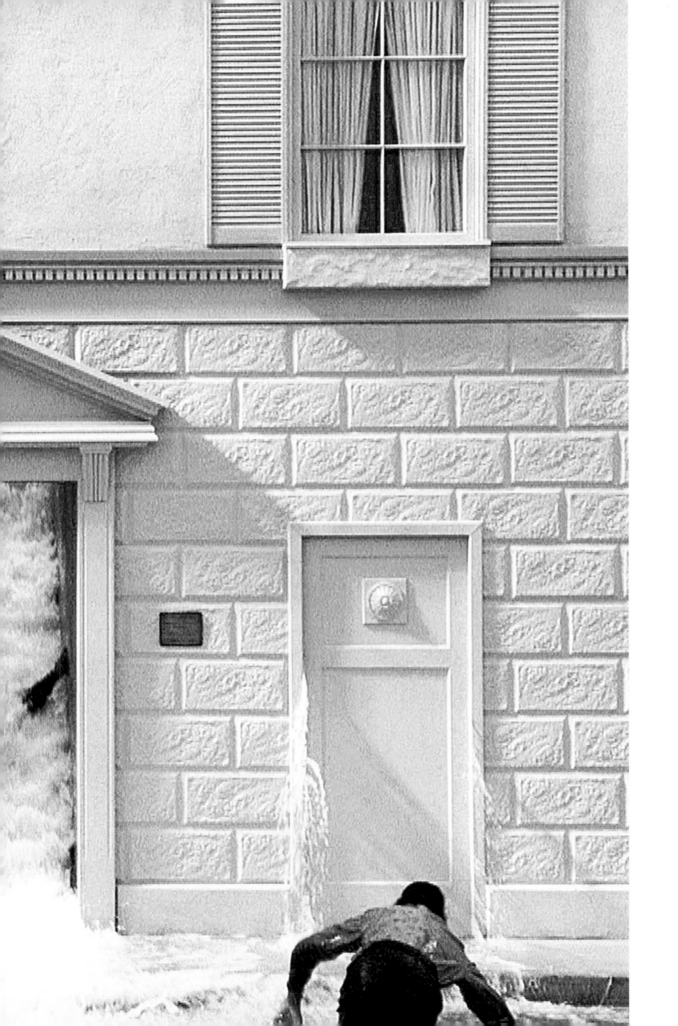

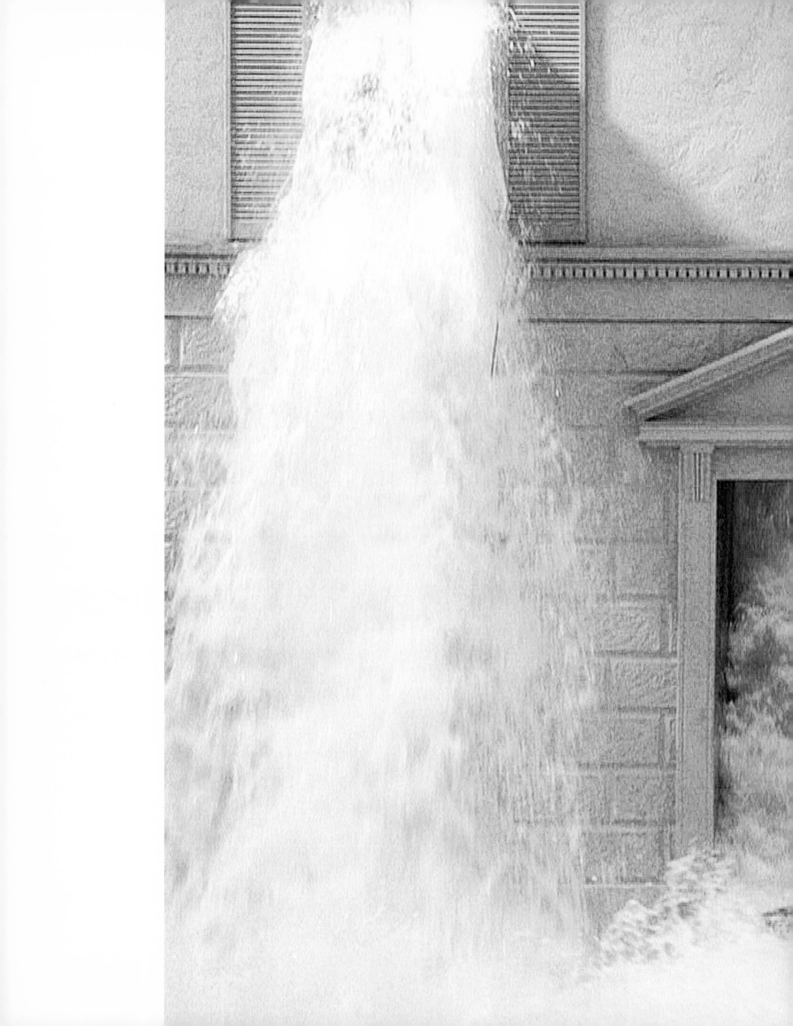

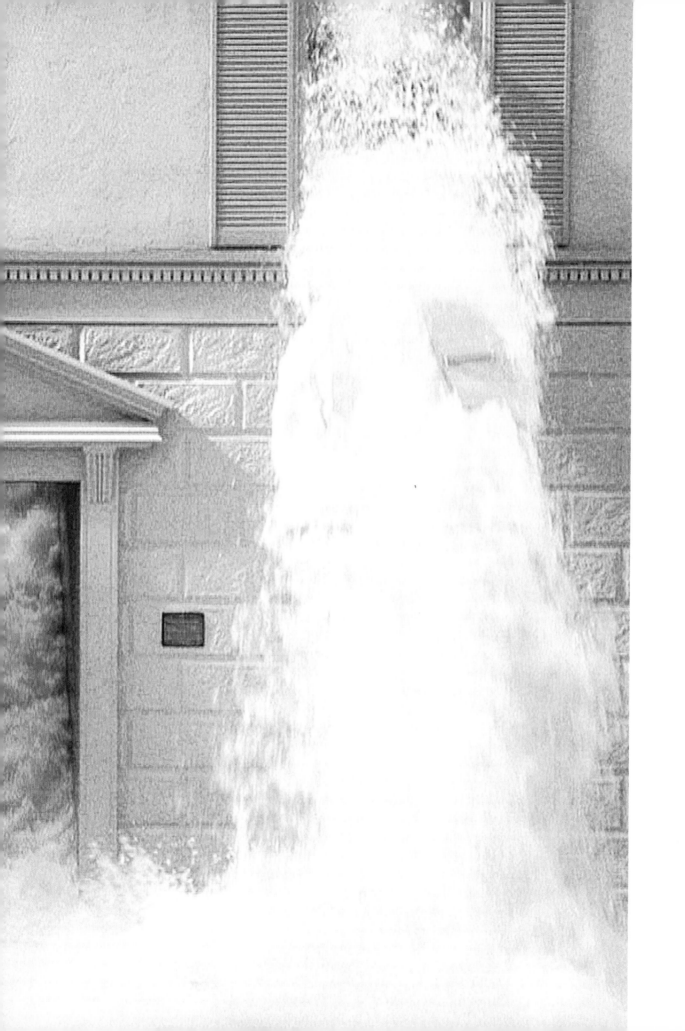

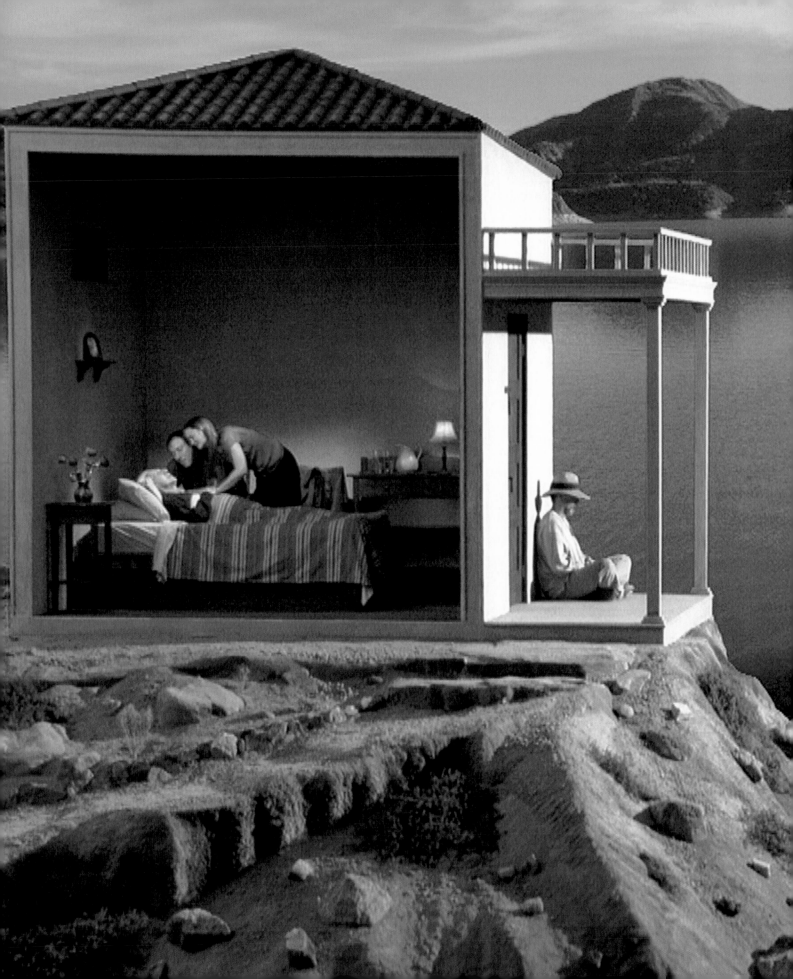

It is late afternoon at the time of the winter solstice. A small house stands on a hill overlooking the inland sea. Inside, an old man lies ill on a bed, attended by his son and daughter-in-law. Outside, another man sits by the door keeping vigil. Down by the shore, a boat is slowly being loaded with the personal possessions from the dying man's home. An old woman waits patiently nearby.

After some time, the son and daughter-in-law must depart, leaving the old man alone with his dreams and fading breath. His house, container of lives and memories, is closed and locked. Soon after, the old man reappears on the shore and is greeted by his wife, who has been waiting for his arrival. The two board the boat, which departs, carrying them and their belongings to the distant Isles of the Blessed. Meanwhile, the son and daughter-in-law return to the house. Distraught, the son knocks frantically at the locked door, but there is no answer. Finally accepting the inevitable, he and his wife once again leave and walk away together down the hill.

THE VOYAGE

It is late afternoon at the time of the winter solstice. A small house stands on a hill overlooking the inland sea. Inside, an old man lies ill on a bed, attended by his son and daughter-in-law. Outside, another man sits by the door keeping vigil. Down by the shore, a boat is slowly being loaded with the personal possessions from the dying man's home. An old woman waits patiently nearby.

After some time, the son and daughter-in-law must depart, leaving the old man alone with his dreams and fading breath. His house, container of lives and memories, is closed and locked. Soon after, the old man reappears on the shore and is greeted by his wife, who has been waiting for his arrival. The two board the boat, which departs, carrying them and their belongings to the distant isles of the Blessed. Meanwhile, the son and daughter-in-law return to the house. Distraught, the son knocks frantically at the locked door, but there is no answer. Finally accepting the inevitable, he and his wife once again leave and walk away together down the hill.

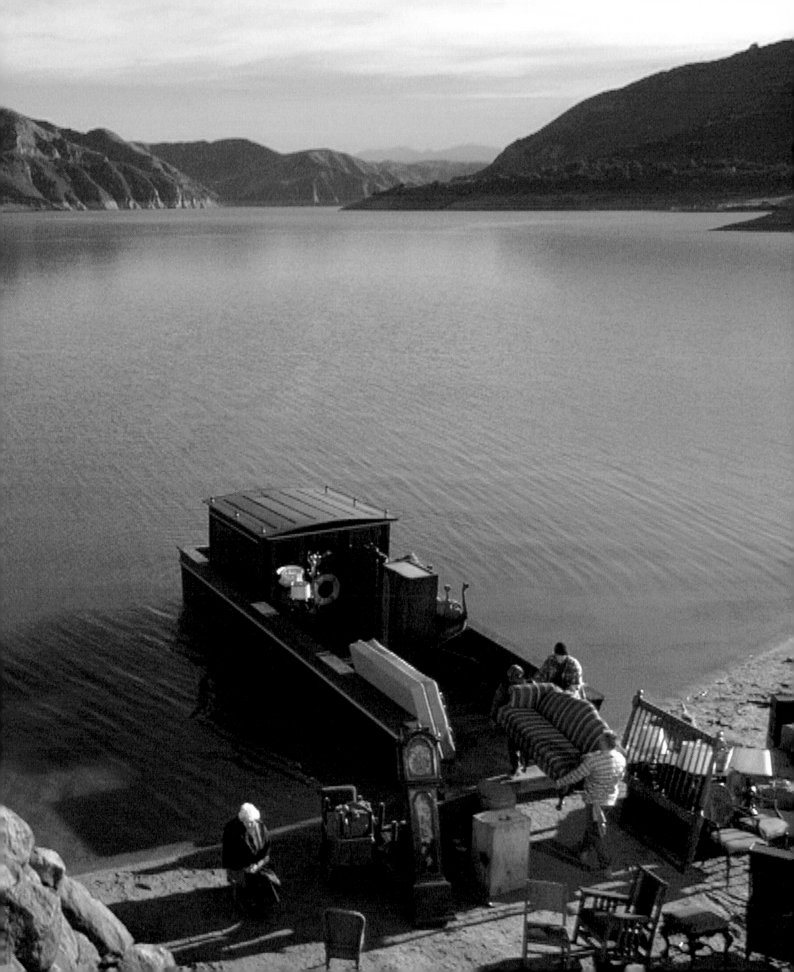

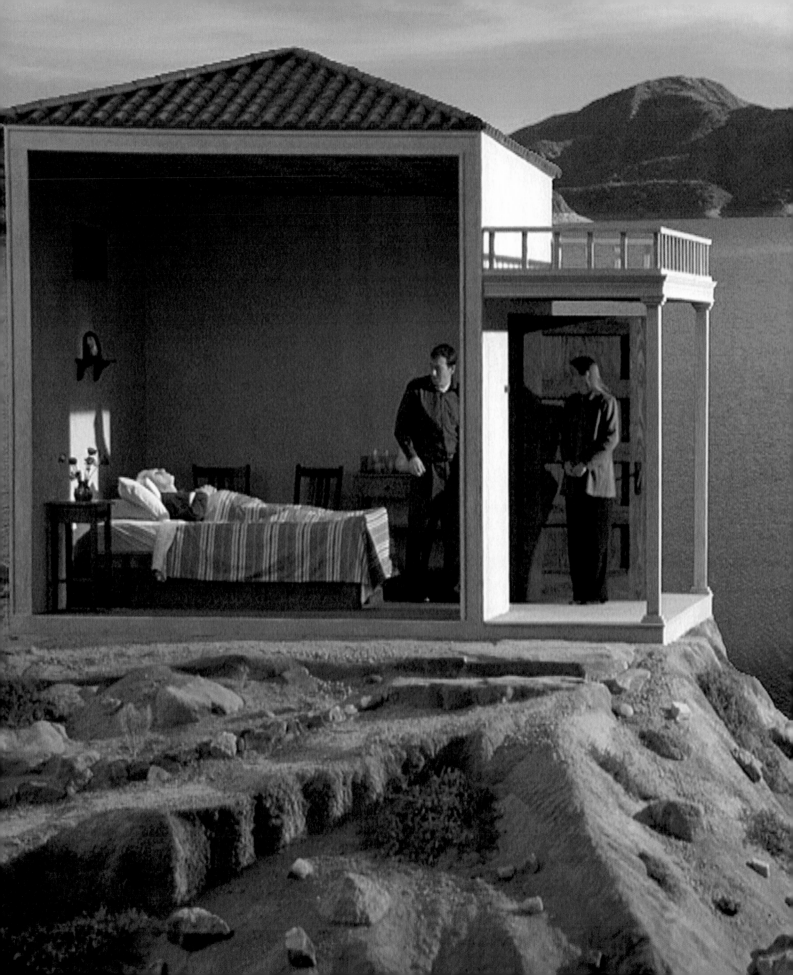

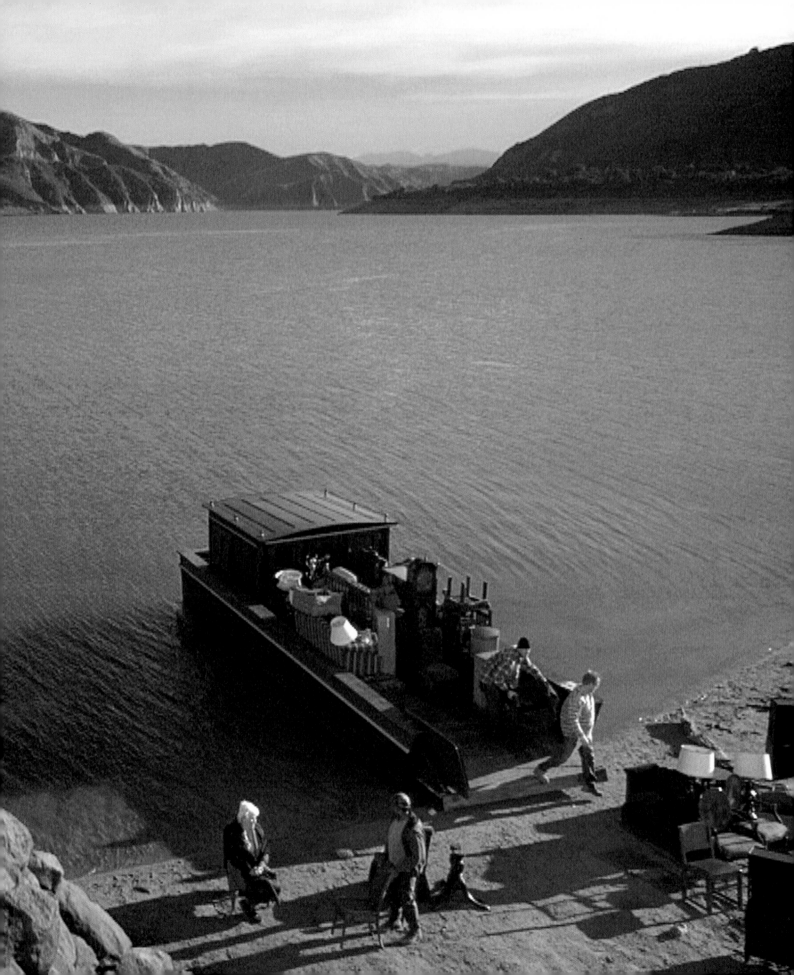

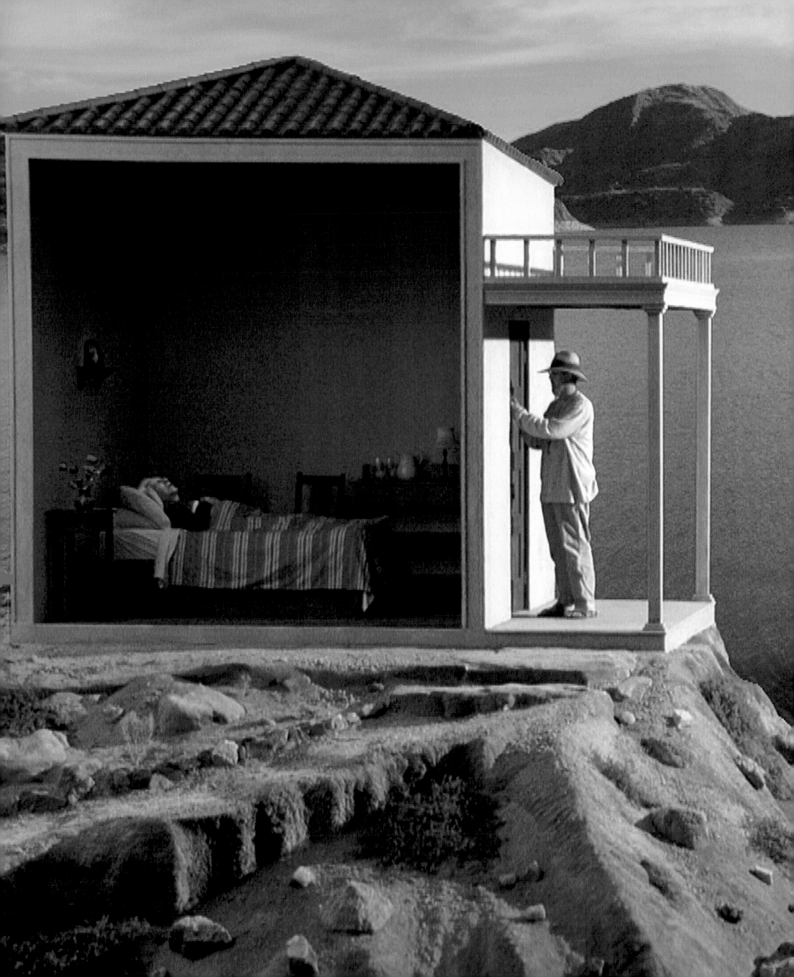

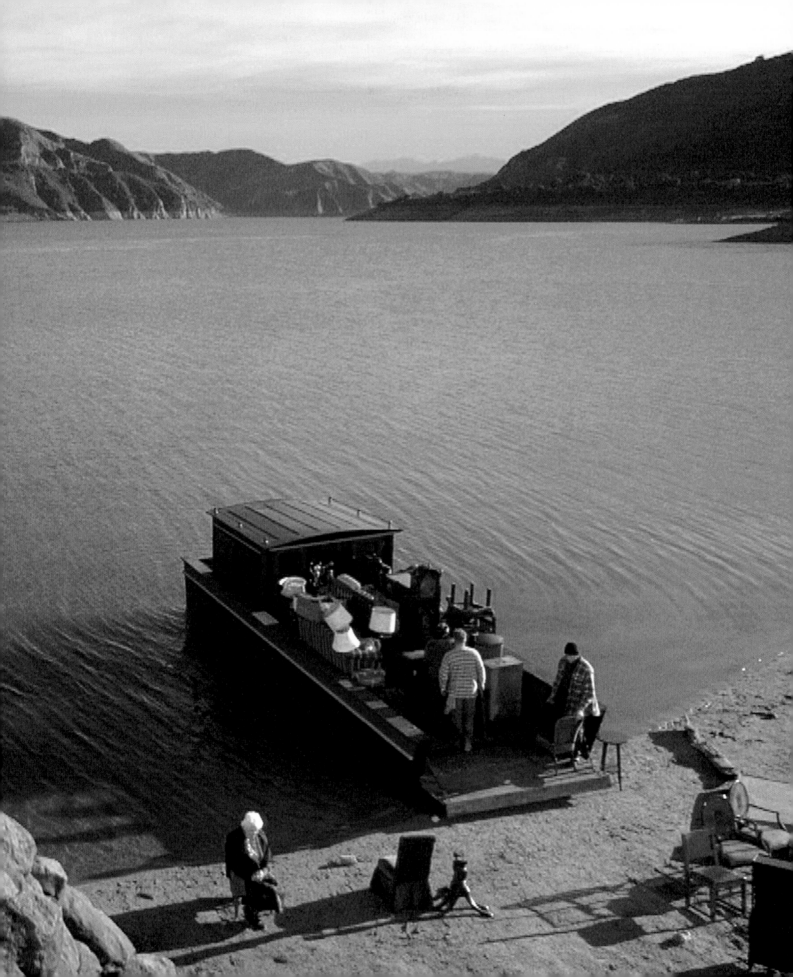

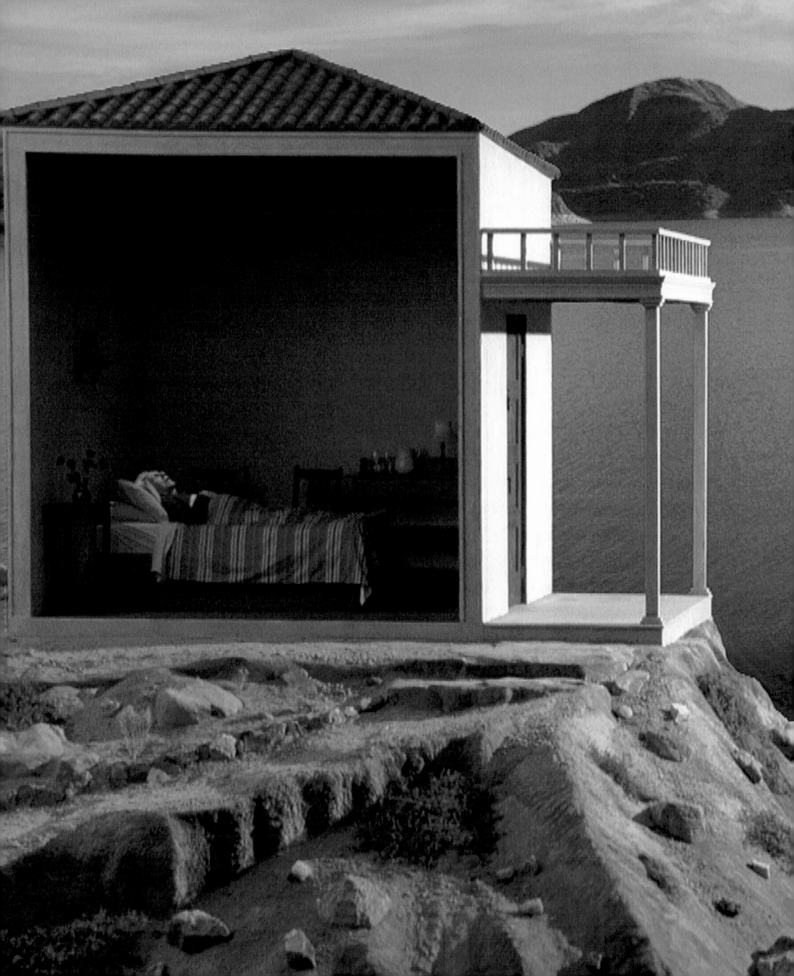

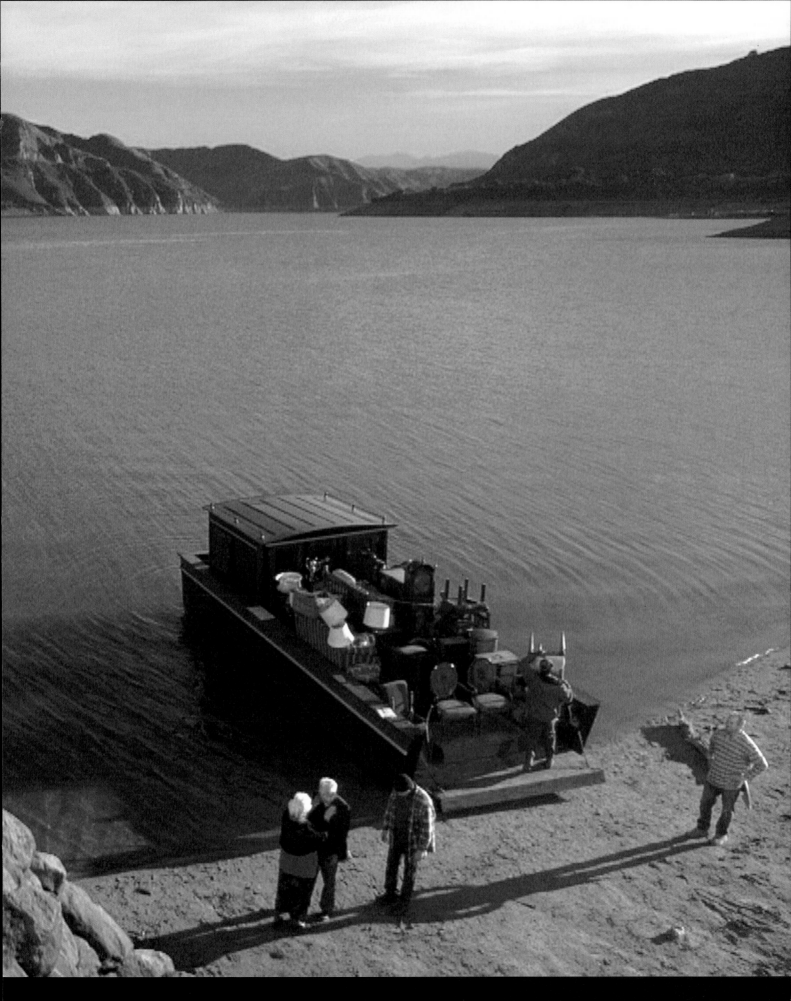

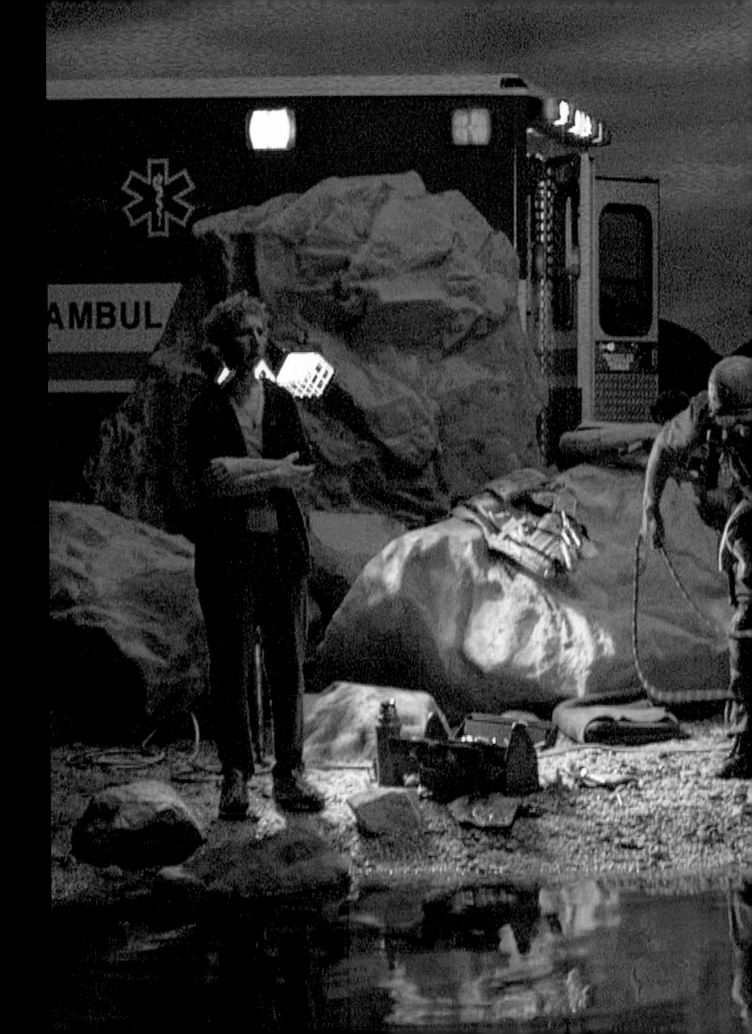

FIRST LIGHT

It is dawn on the morning of the vernal equinox. A team of rescue workers has been laboring all night to save people caught in a massive flash flood in the desert. Exhausted and physically drained, they slowly pack up their equipment as the dawn light gradually builds and the emotional impact of the night's events deepens. A woman stands on the shore, looking off into the flooded valley where her friends and neighbors once lived. She silently waits, filled with fear and fading hope for the fate of a loved one, her son, who will never return.

Eventually, the exhaustion and distress take their toll and, one by one, the four remaining individuals drop off to sleep. All is still and calm. Then, a disturbance appears on the surface of the water and a young man's face emerges. He rises up, limp and dripping wet, and floats up into the sky. The drips falling off his body turn to rain, waking the sleeping people. Unaware of what has occurred, they move to gather their things in the downpour. The light of the rising sun breaks through the rain as they walk off toward the main road. The rain subsides and the light of a new day shines brightly onto the rocks and hills.

FIRST LIGHT

It is dawn on the morning of the vernal equinox. A team of rescue workers has been laboring all night to save people caught in a massive flash flood in the desert. Exhausted and physically drained, they slowly pack up their equipment as the dawn light gradually builds and the emotional impact of the night's events deepens. A woman stands on the shore, looking off into the flooded valley where her friends and neighbors once lived. She silently waits, filled with fear and fading hope for the fate of a loved one, her son, who will never return.

Eventually, the exhaustion and distress take their toll and, one by one, the four remaining individuals drop off to sleep. All is still and calm. Then, a disturbance appears on the surface of the water and a young man's face emerges. He rises up, limp and dripping wet, and floats up into the sky. The drips falling off his body turn to rain, waking the sleeping people. Unaware of what has occurred, they move to gather their things in the downpour. The light of the rising sun breaks through the rain as they walk off toward the main road. The rain subsides and the light of a new day shines brightly onto the rocks and hills.

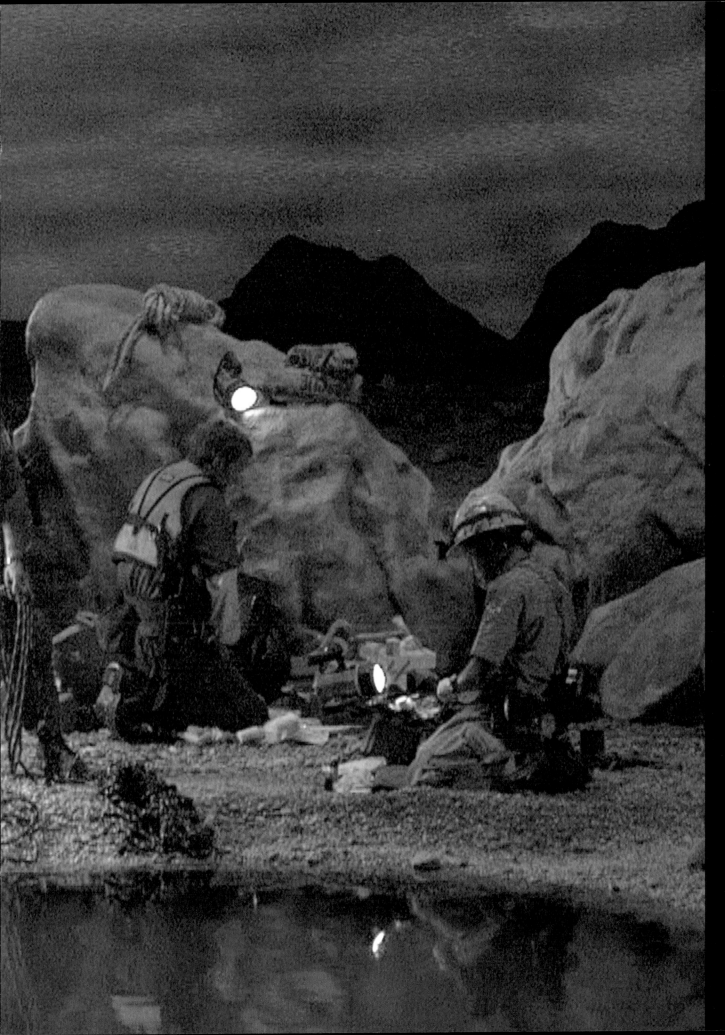

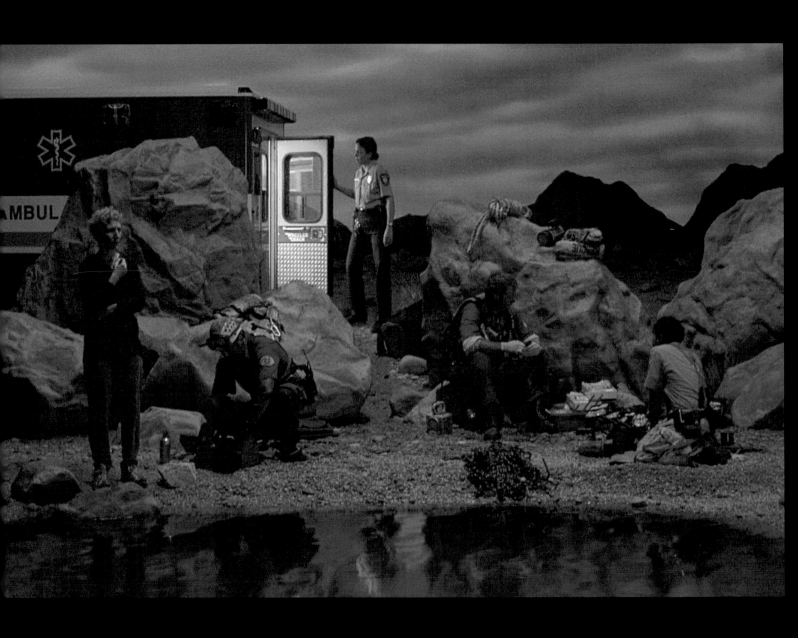

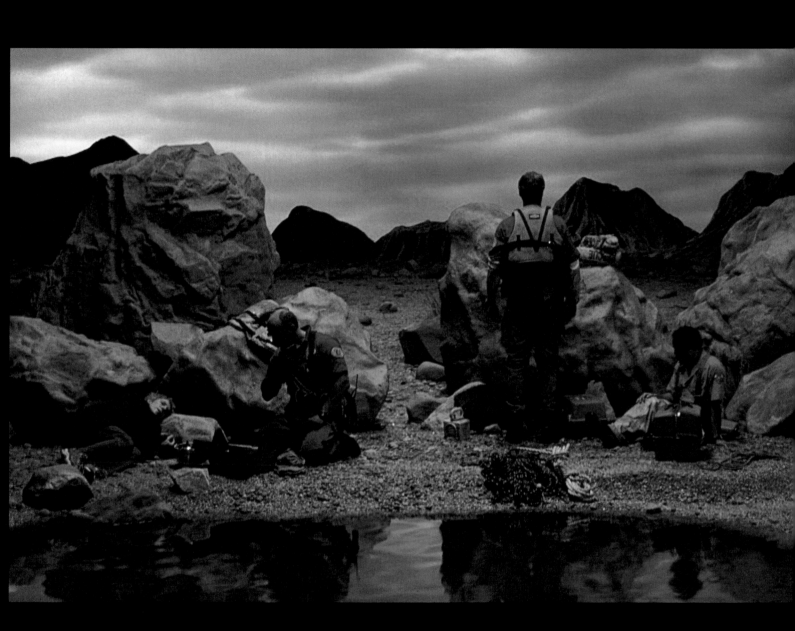

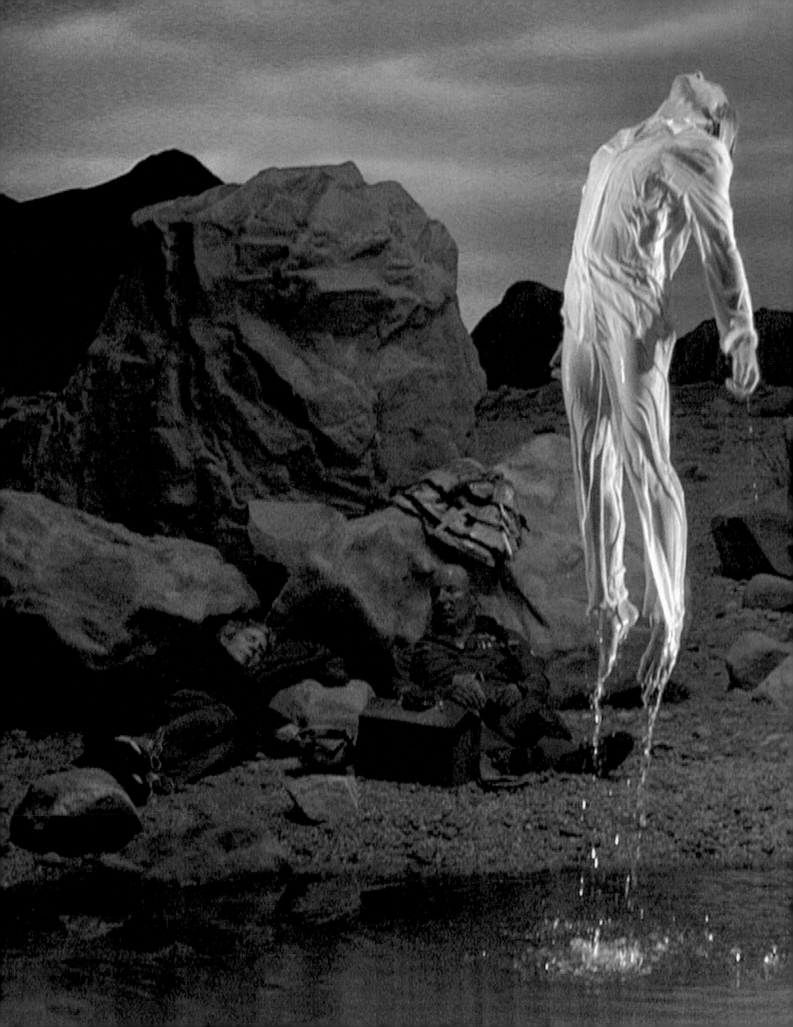

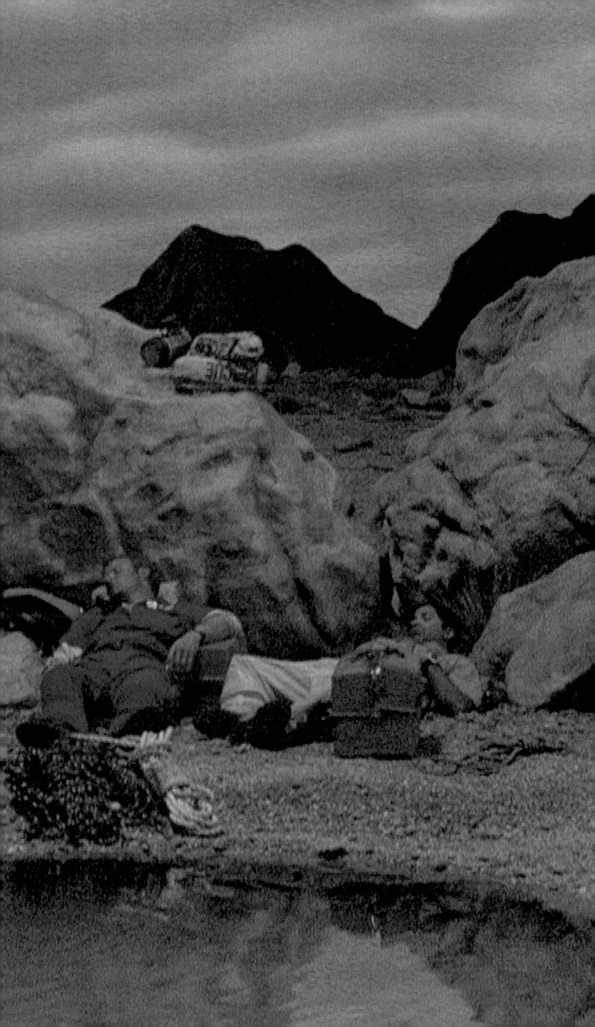

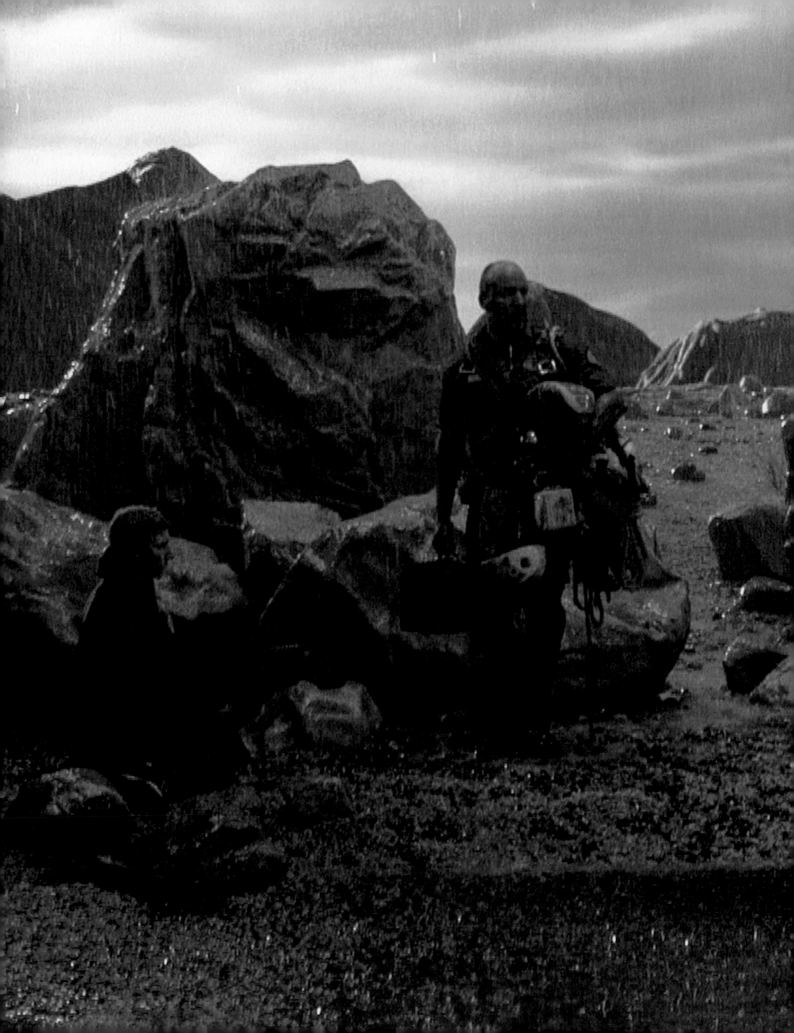

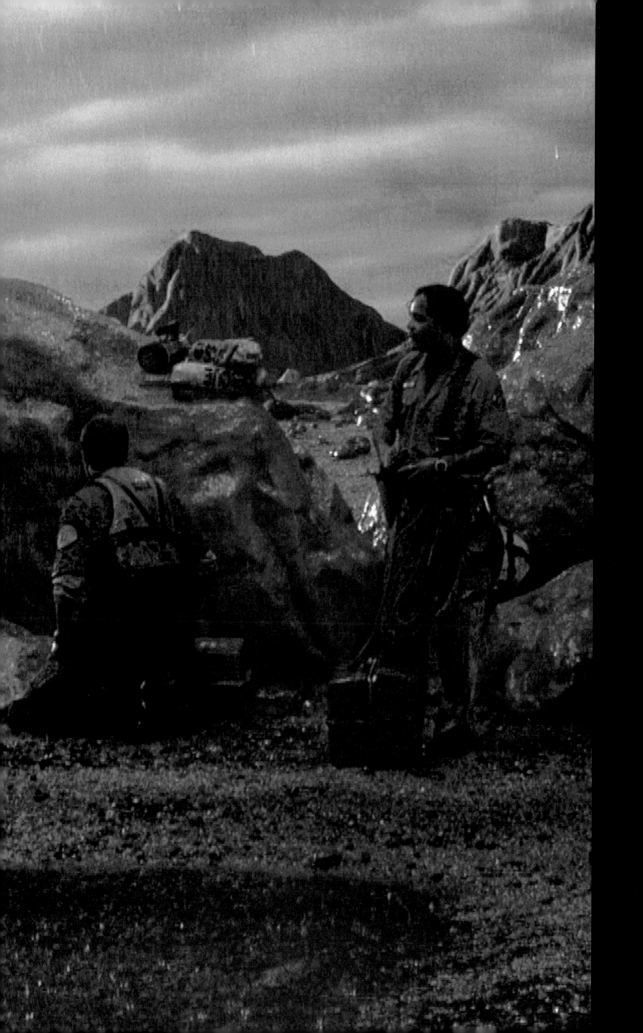

GOING FORTH BY DAY — A Projected Image Cycle in

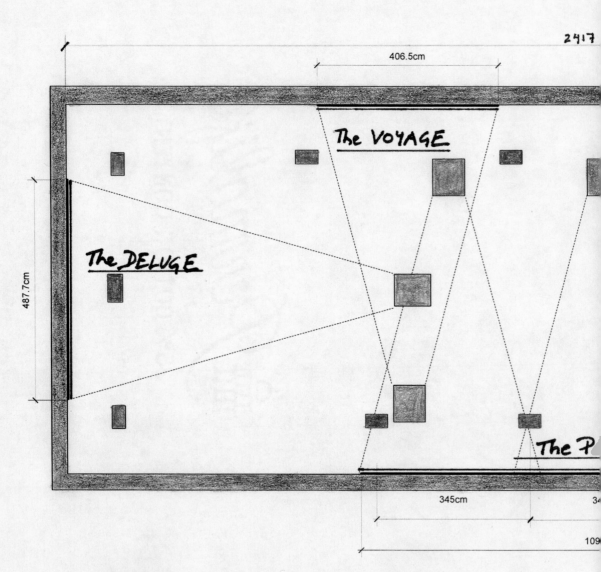

2417

406.5cm

The VOYAGE

487.7cm

The DELUGE

The P

345cm 3

109

1. **FIRE BIRTH** — 487.7 cm × 365.8 cm (16'0" × 12'0")

2. **The PATH** — 1097.3 cm × 228.6 cm (36'0" × 7'06")

3. **The DELUGE** — 487.7 cm × 365.3 cm (16'0" × 12'0")

4. **The VOYAGE** — 406.4 cm × 228.6 cm (13'04" × 7'06")

5. **FIRST LIGHT** — 335.0 cm × 228.6 cm* (11'0" × 7'06")*

* Final image width to be determined on site.

Going Forth By Day is a five-part projected digital image cycle that explores themes of human existence: individuality, society, death, rebirth. The work is experienced architecturally, with all five image sequences playing simultaneously in one large gallery. To enter the space, visitors must literally step into the light of the first image. Once inside, they stand at the center of an image-sound world with projections on every wall. The story told by each panel is embedded within the larger narrative cycle of the room. Viewers are free to move around the space and watch each image panel individually or to stand back and experience the piece as a whole.

The five image sequences are each approximately thirty-five minutes in length and play in synchronization on a continuous loop. Sound from each panel mixes freely in the space, creating an overall acoustic ambience. The images are projected directly onto the walls—without screens or framed supports—as in Italian Renaissance frescoes, where the paint was applied directly into the plaster surface of the walls. The title of the work derives from a literal translation of the title of the Egyptian Book of the Dead, "The Book of Going Forth by Day"—a guide for the soul once it is freed from the darkness of the body to finally "go forth by the light of day."

Going Forth By Day is a five-part projected digital image cycle that explores themes of human existence: individuality, society, death, rebirth. The work is experienced architecturally, with all five image sequences playing simultaneously in one large gallery. To enter the space, visitors must literally step into the light of the first image. Once inside, they stand at the center of an image-sound world with projections on every wall. The story told by each panel is embedded within the larger narrative cycle of the room. Viewers are free to move around the space and watch each image panel individually or to stand back and experience the piece as a whole.

The five image sequences are each approximately thirty-five minutes in length and play in synchronization on a continuous loop. Sound from each panel mixes freely in the space, creating an overall acoustic ambience. The images are projected directly onto the walls—without screens or framed supports—as in Italian Renaissance frescoes, where the paint was applied directly into the plaster surface of the walls. The title of the work derives from a literal translation of the title of the Egyptian Book of the Dead, "The Book of Going Forth by Day,"—a guide for the soul once it is freed from the darkness of the body to finally "go forth" by the light of day".

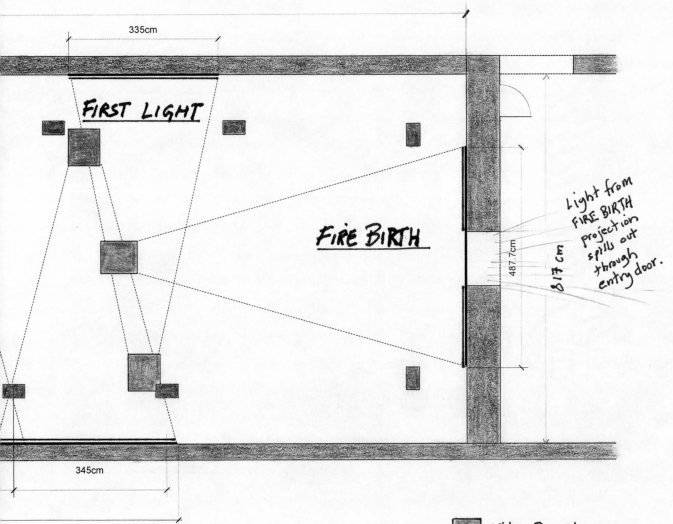

FIRST LIGHT

FIRE BIRTH

335cm

487.7 cm

817 cm

Light from FIRE BIRTH projection spills out through entry door.

345cm

- Playback equipment to be mounted in separate space.

- All walls to be perfectly smooth for image projection directly on wall surface

- Non-image wall areas to be painted medium gray to control ambient light levels. Ceiling to be dark gray.

- No signage or wall labels to be present in projection space.

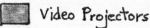 Video Projectors

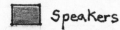 Speakers

All units to be ceiling mounted.

Bill Viola, Deutsche Guggenheim, Berlin, 2002

800 400 100 0
Scale in centimeters

N

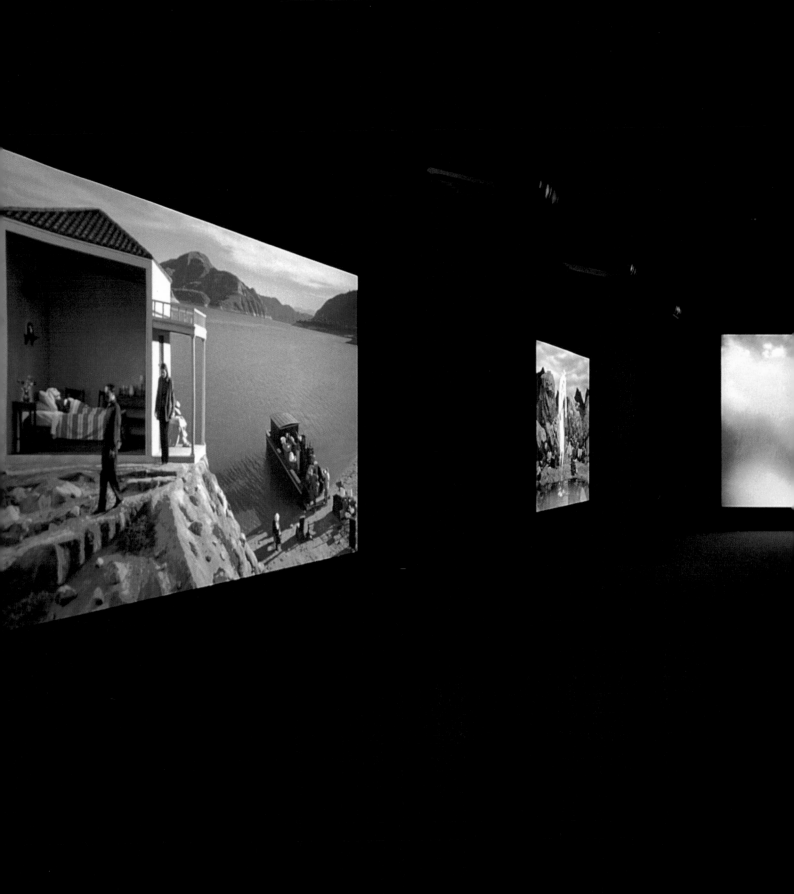

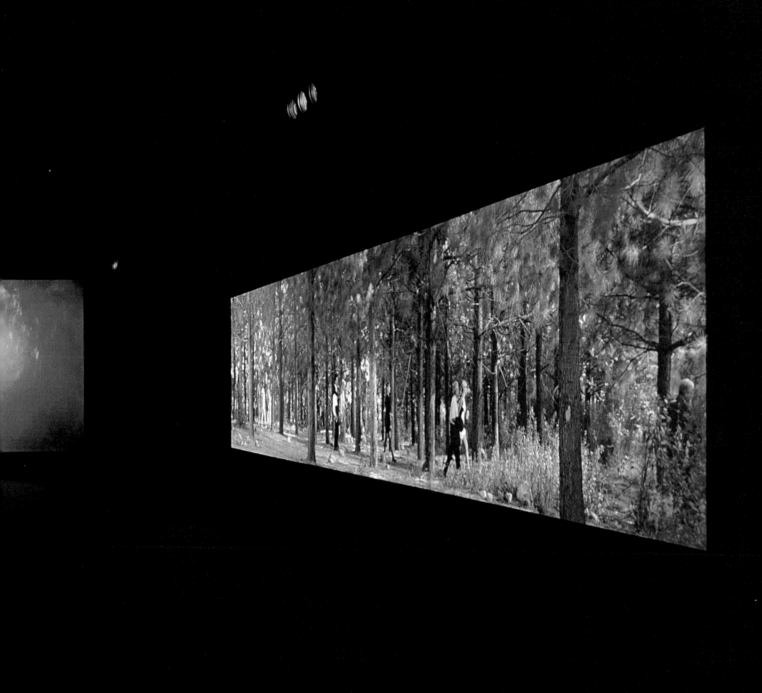

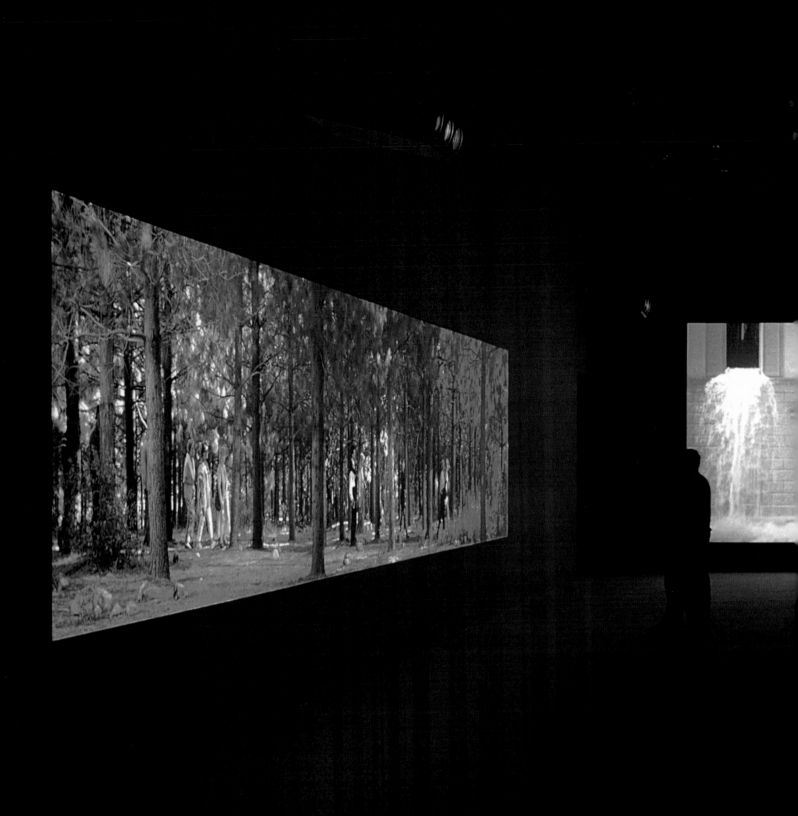

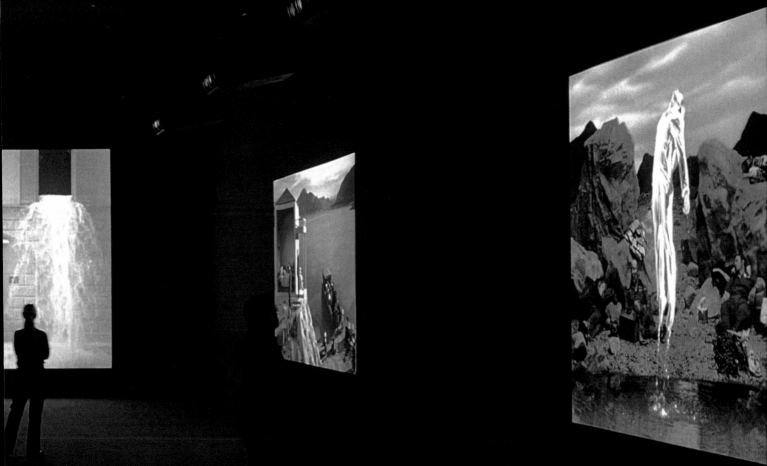

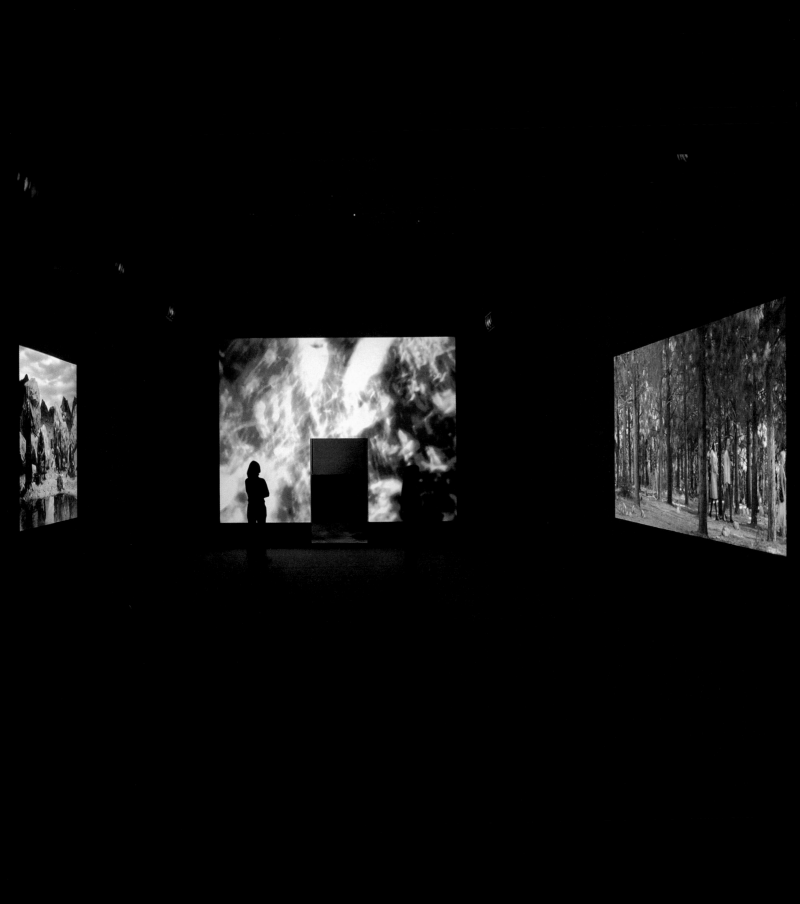

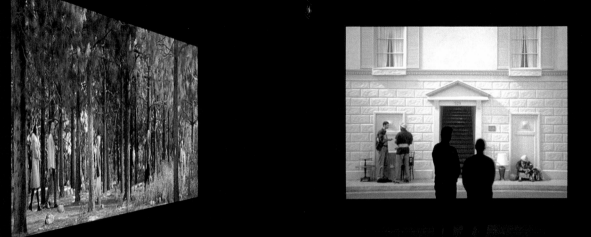

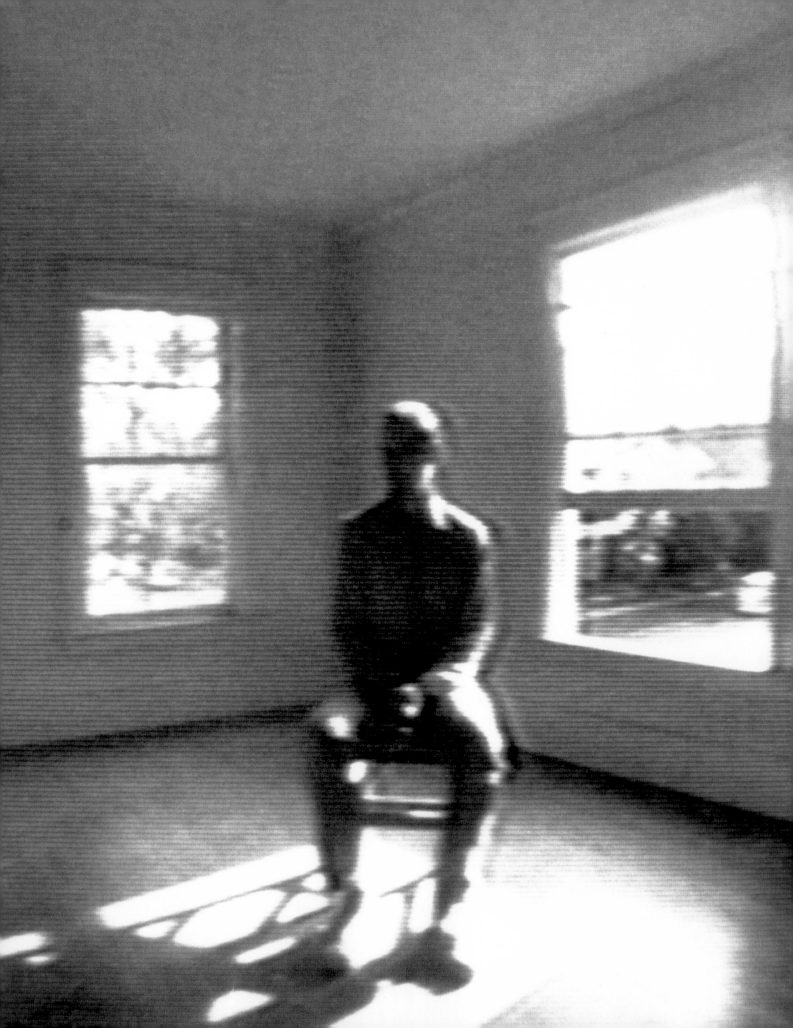

BILL VIOLA INTERVIEWED BY JOHN G. HANHARDT

INTRODUCTION

....NOTHING RIPENS TO REALITY THAT IS NOT ROOTED
IN MEMORY....
—Hermann Broch, *The Death of Virgil*

...THE SEA OF THINGS HE KNOWS HAS NO SHORE...
—Al-Ghazali, *The Ninety-Nine Beautiful Names of God*

This conversation took place in the dining room of Bill Viola's home in Long Beach, California. Adjacent to his home are the offices where his projects are managed, while his studio is a short drive away. During the two days of conversation we experienced mild weather and blue skies viewed from the window and enjoyed when we went out of doors.

Our conversation focused on the origins of Bill Viola's aesthetics and his critical thinking about art, and more specifically, how these views inform his new installation, *Going Forth By Day*, for Deutsche Guggenheim Berlin. There has always been a connection between Viola's art and his life. His family is an integral part of his world and work, as are his studies in spirituality, which he does not abandon in his art. Our conversation revealed Viola's self-reflective view of his art, his intellectual formation, and his worldview.

A few days after I returned to New York City from Long Beach and my conversations with Bill, an experience forced a change in all of our lives in this country. On September II, I witnessed the terrible events that engulfed and destroyed the World Trade Center. From my office window I watched the World Trade Center burn and crumble to the ground. It was something that was so horrifying and so filled with tragedy that one sought images and texts to gain some hope and solace.

Beginning that morning and during the following days as I spoke to relatives, friends, and colleagues around the world, there was an expression of shared pain and the palpable sense that our world had changed. How would we see art after this tragedy and what would artists say; what could they represent in their artwork to give meaning to the world we now find ourselves in?

As I read over the transcript of my conversation with Bill, I inevitably reconsidered our remarks against the backdrop of the events that I had witnessed and was continuing to feel. I was struck by how his project spoke to a world seeking to understand the passage of life and the meaning of existence. The powerful moving-image tableau speaks to cultural meanings and heritages that are informed and transformed through Bill's aesthetic vision. The cycles of life and nature, the resurrection that follows the deluge, are panels that evoke the power and wonder of hope and the eternal return of the future.

Going Forth By Day is an aesthetic text devoid of the postmodern clichés of appropriation and ironic distance from the world in which we exist. It resists the metanarrative strategies that make the past and the forces of daily life a cartoon removed from the sources of pain and redemption that we seek out of our existence. The concepts of justice, fairness, belief, and moral balance surge through Viola's humanistic projections. Out of the darkness, *Going Forth By Day* offers luminous hope.

John G. Hanhardt

JH: When we look at the history of visual culture—how we see the world around us and represent it—we talk about the moving image as being the fundamental change of the twentieth century. From cinema through television and video to the new media of today, there has been very much a continuous progression of moving-image technologies. Your early consciousness was immersed in twentieth-century technologies of movement and representation, and your recovery of that experience is something that's very important about your art and its recovery of self, of family, and the connection that it has to your treatment of the moving image. So many of your videotapes and installations reflect on your family, as well as on issues of birth and death grounded in your own self-awareness.

BV: Yes, and this is not simply *personal* biography. I don't think you can talk about these technologies without bringing in notions of self-awareness and self-knowledge, because the whole idea of media is the creation of an artificial system that literally—technologically, symbolically—reflects the life field. In doing so it embodies much more of the world than meets the eye alone. The filmmaker Hollis Frampton described the movement of the moving image as "the mimesis, incarnation, bodying forth of the movement of human consciousness itself."

You can see evidence of this as you look at the history of Western science and technology. The twentieth century saw the maturation of a functioning surrogate perceptual system first initiated by researchers in the nineteenth century, when scientists turned their attention from the external physical world to the mechanisms of knowing. In the nineteenth century, people like Gustav Fechner, Hermann von Helmholz—who is one of my personal heroes—and Ernst Mach developed the field of "psychophysics": the idea that the mind plays a major role in shaping the perceived form of the physical world. Later, technological advances such as lights, microphones, cameras, and electrical circuits became essential tools for this research in the twentieth century, as experimental psychologists and cognitive scientists sought ways to objectify and therefore study subjective experience.

To trace the roots of all this, you probably have to go back to the origin of the camera obscura. There is evidence of the creation of pinhole projections in ancient China as far back as the fifth century BCE, but the technology was most fully described in the ninth century CE. It eventually found its way to Europe, greatly influencing art as well as science. For example, Vermeer and his Dutch colleagues used the camera obscura in the seventeenth century to compose their pictures. The camera obscura is the idea of a room functioning as the human eye. All outside light is sealed off except for a pinhole in the wall. The wall opposite to the pinhole in this dark room becomes a projection screen for a large, high-resolution, full-color, moving image of the outside world. The image is inverted of course: upside-down as it is on our retina. And they were experiencing this in ancient China. Think of it! These were image rooms—the Chinese called them "locked treasure rooms"—that people could enter to experience the wonder and fascination of the artificial image.

JH: A precinematic moving image.

BV: Exactly. Despite what people think, color and movement preceded black and white and stillness in the history of image making. If the pinhole was precisely cut, this image in the ancient world rivaled the best digital projection systems we have today. Live video projection, which I experimented with extensively in the 1970s, is the mechanized version of the camera obscura. And the phenomenon of a live image liberated from the surface of the retina and blown up to architectural scale was just as compelling to me as it must have been to viewers in ninth-century China or seventeenth-century Holland.

Experimenting with a homemade camera obscura and video projections helped me to understand the idea of the room as an instrument. I grew up with the tacit notion of the room as a container, but here was a living dynamic space where the walls and the empty space they defined were an active part of the experience. Like a lightning bolt, what was background became foreground; it was an inversion of common understanding that has never left me.

JH: Was this in college?

BV: Yes, I was enrolled in the art school at Syracuse University, a small part of a much larger liberal arts university. That meant—thank God!—that I was able to get outside the art department and participate in a wide variety of classes, from religion to electrical engineering. At one stage I was sitting in on a course at the Institute for the Study of Human Perception. I was extremely interested in how we see, how we hear, and how we come to know the world. I felt that these were a vital part of my basic materials, my palette, as an artist. At the same time, I was sensing a deep connection between these scientific/technological concepts and my readings and experiences in Eastern religion, which is all about the knower and the known being part of a larger unity. Hinduism and Buddhism were several thousand years ahead of those modern psychophysicists and perceptual psychologists I was studying. I gradually realized that the act of perception was in fact a viable form of knowledge in and of itself and not merely some kind of phenomenon. This meant that when I held a video camera and microphone in my hands I was holding a philosophical system, not just some image and sound gathering tool.

The video cameras and microphones we had in the student media center were the greatest teaching tools around for developing self-awareness. They took you out of your own ear to hear things in a new way, out of your own eye, and out of the subjectivity of your own personal experience. Using them immediately involved you with perception and cognition whether you wanted to or not. To this day, when people bring home their first camcorder, they turn it on their kids, their pets, and they immediately play it back on the TV in their living room. And they see their kids and the dog, and they like it. But then, all of a sudden, they notice things and say, "What? We have those ugly curtains? God, we *have* to get new curtains!" [Laughs] Suddenly, they're seeing their world from a detached viewpoint, which previously we couldn't do without specialized training. So, experiencing subjective perception of the world through the objective eye of a lens is really one of the great contributions that these tools have made.

JH: This leads me to think of your work *Chott el-Djerid* (*A Portrait in Light and Heat*) [1979] with its representation of the mirage, the liquid atmosphere of light and reality transformed. And I was convinced that it was by seeing it through the eyepiece of the camera, on the monitor, that the process of discovery happened.

BV: Completely.

JH: It's so tangible that one *feels* a dialogue with the fashioning of the image through the process of your making it. It's phenomenological, powerfully so, which is why video has become, in your hands, such an extraordinary medium.

BV: John, you just jogged something in my mind about shooting the mirages. I think what's never really been discussed is that what you're looking at is *only* made possible by the camera. I mean, you cannot perceive mirages that way. You are looking at your *desire* to enter the mirage, which physical reality is preventing you from doing when you're there. Because the more you approach it, walking across the vast plain in the desert or driving on a road in the summer heat, the more it recedes. You never get to the mirage in real life; you can't bathe in the image.

JH: And there is also the role of the telephoto lens to consider here.

BV: The telephoto lens is an extreme limiting device: it narrows down the wide field of view to a small slice of space, magnifying distance but cutting out everything else. We cannot see the world in this way with our eyes. It reveals the far borders of the view, the edge of the real, the distant horizon just before things drop off into the unseen.

The ancient Egyptians had a word for the "underspace" beneath the horizon; they called it "Nun," the inverted space below the ground, shaped like the dome of the sky above. English translators of the Egyptian *Book of the Dead* have used "abyss," the same word we use for the vast featureless plane at the bottom of the ocean. Now, the structure of this cosmology is very interesting. To the modern mind, when you put two halves of a sphere together you have a model of the globe, with the equator, the ultimate horizon line, running along the seam.

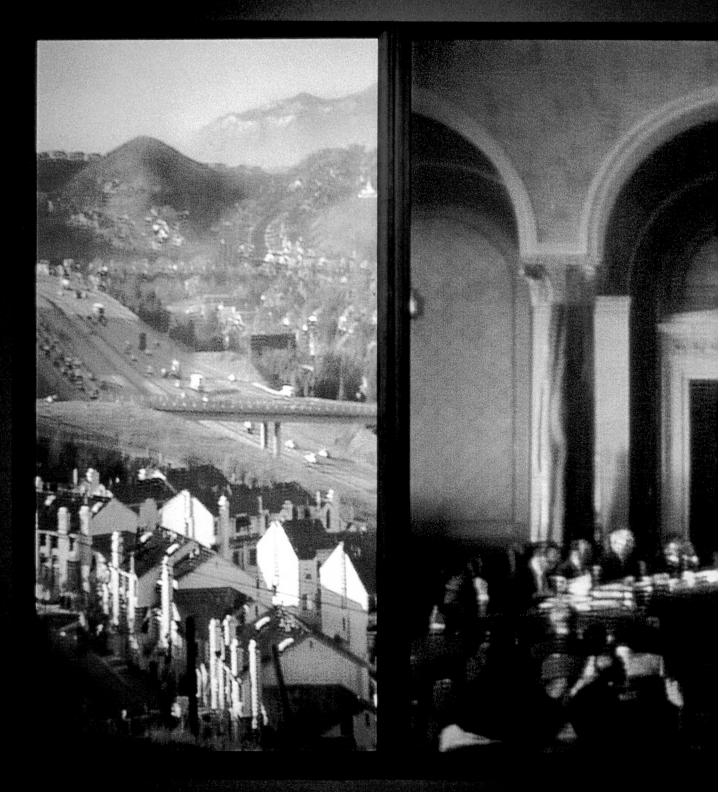

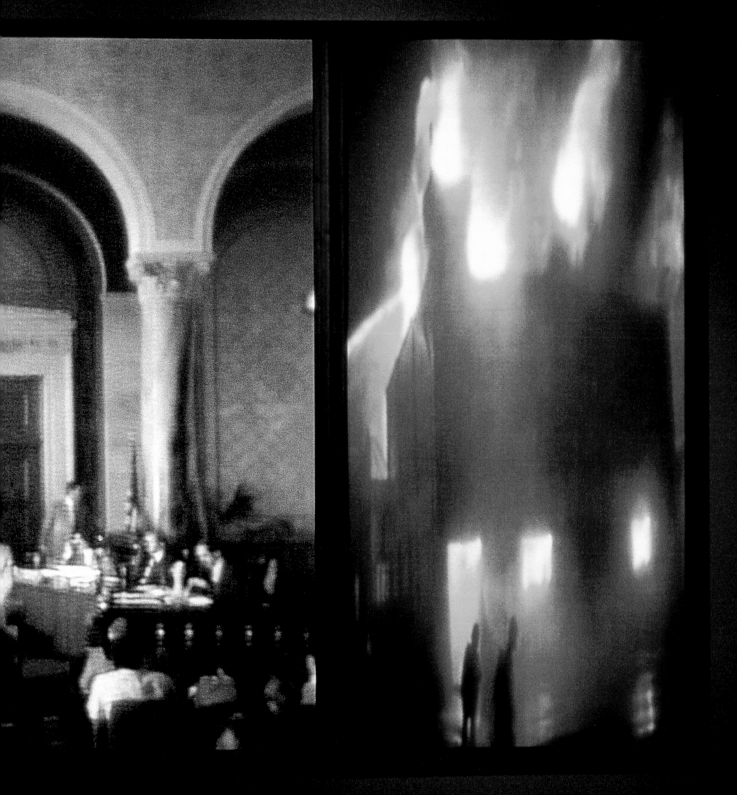

The Egyptians' model arose from their speculating as to what happened to the sun—the supreme deity and ultimate power—when it dropped below the horizon in a reddened and weakened state at the end of the day. They reasoned that it must dip into a vast underground sea of impenetrable darkness, the primordial waters of Nun, where it continued on its journey, tracing the inverted arc of its daytime movement across the Underworld below. Finally, it reemerged in the east at dawn, rejuvenated and reborn, ready to continue on its endless cycle.

For the Egyptians there were actual places on this earth where there was a connection to the waters of Nun, actual portals to the Underworld. One is the cave, where you enter right into the earth and pure darkness. And another place is the desert, the desolate, empty space where existence is tested to the limits.

The desert experience is archetypal. You can go to places like the middle of Death Valley here in California or the Bonneville Salt Flats in Utah, and you are the only vertical form for fifty miles. That's about as basic an experiential state of being on earth as there is. [Laughs] There you are—your body like a post with a conscious mind on top like an antenna—standing upright on this vast flat plain that stretches out from you in all directions as far as the eye can see.

This is why the desert has always been the locale of visionary experiences. Because when you're in the midst of infinite space and all the visual clutter has been taken away—when you can see all of the earth to the horizon and feel the dome of the sky enclosing all above you—the center becomes everywhere. It becomes an inner experience as much as an outer experience.

And now you're out there, and you have this camera. You pick up that camera and at once realize that this giant experience, where you were about to take some out-of-body, ecstatic leap, cannot fit through this tiny lens. I mean, I remember being out there in the desert many times like that. I just wanted to stop and lie flat on the ground and soak in reality, everything at once. But here is this device, this instrument that is cutting out about ninety percent of the sensation of being there. It's got a little black hole as its center, a small aperture, an eye without a mind. Once you put your eye to it, you're not out in the vastness anymore.

And then, with a telephoto lens on the camera it is showing even less of this big world than what you're trying to see all at once. And that was the way to get into the mirages! The way in was by cutting out an enormous amount of what I was seeing and narrowing it down to this tiny little portal. Then, suddenly, when you do that, the mirages are completely here; you're in their world.

JH: Fantastic. Your description of the video camera sounds like a camera obscura.

BV: Yes.

JH: The video camera/camera obscura reveals a new world.

BV: Yet it's a world that exists in this world. I mean, everybody knows about mirages. They're a part of our world, and that's what fascinated me about them. I was always looking for things on the edges, in the seams, hovering on the borders but real. And mirages are about the most real of the unreal things that exist. They're not some kind of hallucination or fantasy.

JH: How and when did the spirituality that has informed your art, and is so much a powerful part of your thinking, begin to emerge in your consciousness in terms of researching it and thinking about it as you were making your artwork?

BV: It's been so long now I don't think I can pinpoint any one area of experience as being essential or formative. But when you were speaking, I did think of one event from my childhood.

I remember one time when my grandfather came up from Florida to visit us at our apartment in Queens, New York. He came into the room that I shared with my brother, Bob, just to see our toys and spend time with us. I must have been about eleven years old. We had the window open; it was summertime. And he went over to the window, looked out, and said, "What's that sound?" I said, "What

sound?" And he said, "*That* sound. Are we near the ocean?" I knew that we lived far from the sea. I went over next to him to listen, and for the first time in my life I heard the "undersound" of the city—the accumulation of all the traffic and all the people's movements—this low-level, deep rumbling sound. It was constant and continuous, but I had never noticed it. It's the sound you can hear when you're standing on a bridge looking out at the city, with the evening air still and nothing moving nearby. This undersound exists at all times, even far out in the desert. And once I had heard it, I could never not hear it again. I think of it now as the sound of Being itself, and I've used it in my work many times.

JH: Through your art you convince us of what you believe in, and obviously this comes from experiences that you haven't forgotten, that have left their traces on you and, through you, on your work as an artist. You recover those moments.

There is the extraordinary experience of temporality in your installations and the understanding of materials. It's interesting how your poetic fusion of these elements draws from all the points in your life. Family, upbringing, college, the generational time that you were privileged to be part of—all took concrete form in your use of video, this new medium that was made accessible to you at college.

BV: It's probably always like that for artists. At a certain moment things coalesce from a number of different directions or avenues, and you're at the focal point of that. We are all products of our historical time. Who we are has a lot to do with where we are, the particular random circumstances we find ourselves in. In terms of the very deep-seated influences that one is given in childhood, for every one of them you remember there are scores more that remain submerged in the unconscious, only visible as glance or gesture—what we call personal characteristics.

The most beautiful thing about consciousness is that it's not simply a registering/recording device—it's a transformative instrument. It takes in experience, translates it, and reformulates it. This capacity is at the root of our creativity. It is the heart of who we are as human beings. Now this is a very deep, deep thing, and a very extraordinary thing, because that transformation brings something new into the world. New connections, new objects, new ideas, something that never existed before. Biologically speaking, it is only women who innately have been given this gift: "For she is the place of a divine manifestation," as the Sufis say. This is why the feminine principle is at the root of all artistic practice, and it is also why art has always had a threatening aspect to the established power structures.

JH: One of the achievements of your recent work, including *The Quintet of the Unseen* [2000] and *Surrender* [2001], is your engagement with art history. You forge something that is informed by it, not simply mirroring it or responding with postmodern cliché or ironic, self-reflexive quotation. Your ideas—of perception, science, religious teachings, spiritual texts, art history, cultural history—inform and transform your vision in and through the artwork itself, and it's this that I want us to focus on next.

AFTERNOON

JH: Having discussed moving-image media, your origins, and the process of your self-discovery as an artist, we have come to the recent years and your recovery of issues within the classical traditions of humanism. For example, Pontormo's relationship to *The Greeting* [1995] sets a basis for your recent work, including the Deutsche Guggenheim Berlin project, *Going Forth By Day* [2002]. Yet we've talked about the issue that your art is not about interpreting or representing other art forms; rather it is about creating a dialogue with Being. So, perhaps you could address your dialogue, as it were, with the great artists you rediscovered such as Pontormo.

BV: Well, to start, when I was in art school in the early 1970s, historical painting was very consciously and deliberately rejected as being laden with dubious religious dogma and irrelevant to our contemporary world. The art being made then just seemed so new in appearance and unprecedented. The mantra that rang in the halls was "form, not content." This was the peaking of the Bauhaus-Duchamp axis in twentieth-century art. The work had to be about the understructure: concepts and ideas, visual form, language and texts. There was a strong presence of a type of experimental methodology in the practice of making work, a systematic approach of reducing things to their essentials and substituting variables in a disciplined way to achieve results. This was even present in body or performance art, the least formalistic of all these art forms.

JH: And then, just after university, you went to live in Florence.

BV: I went over in 1974 and returned to the U.S. in the early part of 1976. I was the production technician in one of the first video art studios in Europe, Art/Tapes/22 in Florence, located on via Ricasoli, one block from the Accademia and Michelangelo's David. An energetic and generous Italian woman, Maria Gloria Bicocchi, had created a studio for international contemporary artists to create artworks in the new medium of video, and she invited me to work with her there.

I made several videotapes while in Florence, and showed for the first time a video installation in Europe, *Il Vapore* [1975], presented at an experimental exhibition space called Zona. But more important than this was the experience of seeing all those great works of the Renaissance—the frescoes, paintings, sculptures, architectural spaces—in context and liberated from the pages of art history books. At first it all didn't sink in, at least not consciously.

Ironically, the breakthrough came when I was ignoring the visual and focusing on sound. While I was in Italy I constantly had my audio recorder with me, and I have very few pictures from this period. I started to make a series of stereo sound recordings of the reverberant spaces inside the churches and cathedrals. I was trying to record the sense and presence of space itself, and sound is much more suited than the visual to do this. So, through my microphones and headphones I began to "see" not just the artworks themselves but also the space and context in which they were in. This was not a museum—there were no pristine white walls and silent galleries, and religious services took precedent over art viewing. The works were connected with the community and the architecture and not necessarily situated for the best viewing angles typically found in the art books. I began to see the image as an element in service to a larger system, one that included my body and physical experience.

JH: And that would become a characteristic of your own work.

BV: Yes, obviously a lot of my ideas for installation came out of those experiences in Florence. I saw the roots of the artificial image as an architectural spatial form, going right back to Egyptian tombs and the walls of Paleolithic caves, to the tradition of the walk-in painting. I couldn't look at museum exhibitions in the same way after that. It was all installation, and it always included sound. I knew then that sensory, visceral experience was my medium. The images added Mind, bringing an intangible dimension to the fixed concrete space of the room.

Seeing the frescoes in this light was very evocative. They linked two areas I felt very close to: literature and visual art. The works were for the most part based on texts. The artists designed iconographic plans, composing the sequence of images to tell a story. But they did this in three-dimensional space. If needed, they even painted in "virtual" architectural elements like cornices and pediments that were not in the existing architecture. One of Giotto's greatest

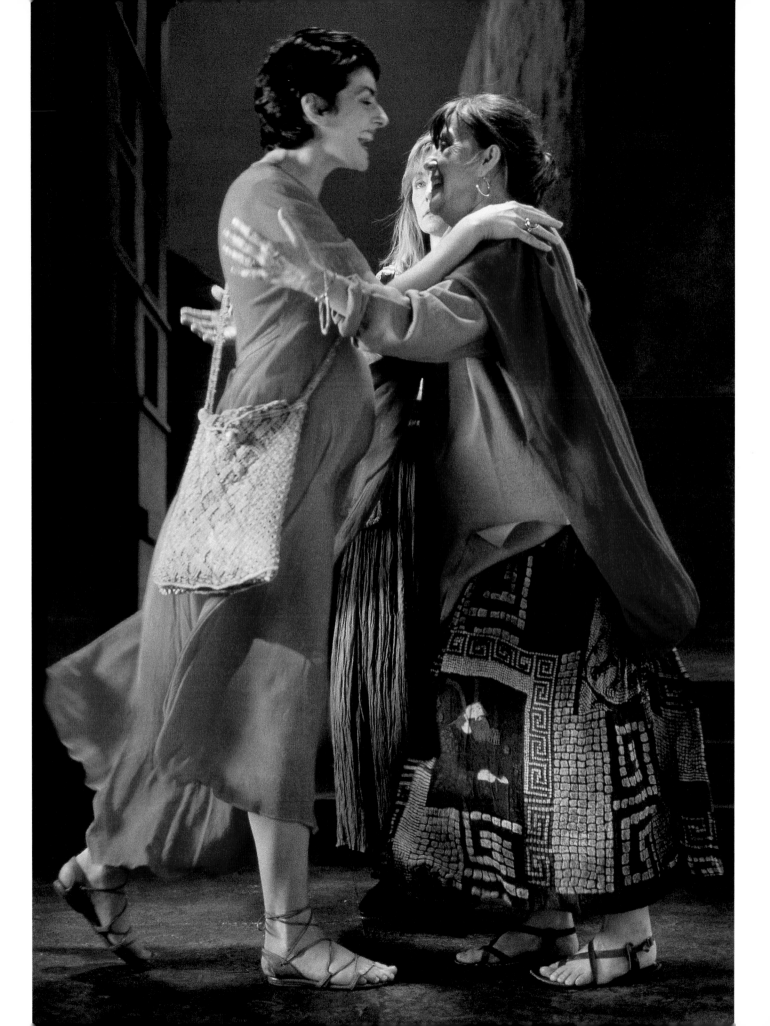

masterpieces, the Scrovegni Chapel in Padua dating from 1306, is a giant three-dimensional image that you physically enter. All wall surfaces and the ceiling, every square inch of the chapel's interior, were painted by the artist. It is one of the greatest works of installation art in the world.

In addition, time entered into the equation in these Italian works in a big way. As you moved through the spaces, things appeared, and the image sequence unfolded in time through your body's movements, not just your eyes'. Most of the great fresco cycles were narratives where the viewer literally walks the story. The artists had to think in spatial cycles and image sequences. We can see them struggling to represent the unfolding of sequential time.

Giotto was the master, and the most groundbreaking, in this way. Not only was he one of the first to deal with representing narrative sequence in chronological time, but he also did it on a grand scale. He was depicting the onset and aftermath of human emotions in the form of the fleeting gestures and facial expressions of his figures. This was extremely radical and new at the time. All of this lends a very cinematic character to these works for the modern eye. Fresco cycles read like large-scale storyboards. I think of them as some of the first movies—they were also presented in public spaces.

JH: After Florence you stayed in Siena?

BV: Yes, I stayed in Siena for a month in 1977 as cameraman on a PBS documentary about the city and its culture. At any opportunity I could get I was in the Pinacoteca Nazionale, the great collection of historical paintings. There I saw for the first time the Sienese masters of the fourteenth and fifteenth centuries: Duccio, Lorenzetti, Giovanni di Paolo, Master of the Osservanza—artists all very different from the big art stars of Florence. Their work was part medieval, part Renaissance, eschewing the photorealism of the optical method in favor of a subjective geometry based on feelings and a deep spirituality.

However, I remember standing in front of those works and saying to myself, "Why am I doing this? I don't like this art; I don't get it."

It was the weirdest experience, but I forced myself to stay there, to try to understand them and to feel something from them. I thought I'd failed because part of me refused to accept their work. I was much more interested in the contemporary art of the time.

But the experience never left me, and today I'd have to say that those days in Siena are among the most vital parts of my foundation. These are now some of the artists that I most dearly love and draw the most inspiration from. [Laughs] It was like the unconscious part of me was digesting it while the conscious part was spitting it out!

The turning point, at least consciously, came in 1984 when I decided to visit the Prado while on a stopover in Madrid, on my way to present work at the San Sebastian Film Festival. I went to the museum jet-lagged and walked into those rooms. The Prado was the best possible museum that I could have been in at that point in my life. There it all was, great works of both the Flemish and Spanish traditions, seemingly disparate I had thought but brought together thanks to the particular circumstances of Spanish history and politics. Bosch, van der Weyden, Memling talking to Velázquez, Zurbarán, Ribera, Goya. The old masters hit me full force on that trip. I barely got out of the room that showed Goya's *Black Paintings* alive.

JH: Why did it happen then?

BV: I guess my guard was down from being so physically exhausted, so that it wasn't an intellectual experience anymore. I just fell into those paintings in a way that I never had before, and that experience opened a huge door for me.

I think what opened up for me that afternoon in the Prado was the idea of content. It really sunk in that the old master tradition was *all* about content; form and technique were in service to this. It's about the human stories, about the depth within people—consciousness ultimately. Personally, I think that this tradition is a testament to living consciousness. The interaction between yourself and these paintings plays out through Being. It's an ontological, not epistemological, encounter and the forms that this consciousness can take are as varied as the different styles of paintings. At the

time, I was unprepared to grapple with that, to grasp that. It dawned on me later, slowly, along with the realization that I was working with the perfect medium to align all of these growing discoveries.

JH: How did these art-historical influences begin to emerge in your work?

BV: By the time that 1989 came along, art making for me could no longer be a technical exercise. I was fighting with this. I had a project going with a small museum in Massachusetts, the Brockton Art Museum—a plan to explore the interactive capabilities of the new medium of laser disk—and I just couldn't focus on it. Instead of canceling the project, I asked them to change it to something I wanted to do: a triptych. They agreed, and I created *The City of Man* [1989].

Triptychs interested me at the time. They were "multichannel" installations—like what I was doing with video—three simultaneous images existing in parallel, creating a dialogue through multiple reference points, instead of the familiar monologue of sequential editing. Also they were sculptural/physical objects, evolving out of church altar retables and reliquaries: the cabinets and containers for saint's relics and for other special sacred objects. Paintings and visual decorations were eventually added to these, and finally the hinged doors remained, but the cabinet was gone. Now they were containers for the image. The opening and closing of the panels to reveal and conceal images and order the sequence became a ritual act tied to particular rites and the holy calendar. In convent hospitals this image ritual became part of a prescribed prayer meditation for healing the patients.

What really caught my eye came from the overall structure of the triptych: the three images side by side, the familiar Heaven, Middle Earth, and Hell in the most basic form. From my studies in Eastern philosophy I was able to see this as the expression of a philosophical system, a form of human consciousness. The tripartite universe is a cosmology present in many diverse cultures. It is a spiritual reality—a mental structure as much as a physical one—latent in the contemporary mind regardless of an individual's religious experience. For this reason I saw the work I was about to make as more than

simply appropriating a form from art history. It was an embodiment of human consciousness that would resonate within the individual in ways I couldn't predict or describe.

Then, I had to physically create it, and so I opened up an art book and looked at a variety of altarpiece triptychs to see how the proportions worked. I looked to the Northern European artists with their optical precision and clarity, and I settled on a work from the fifteenth century in Flanders, by Robert Campin, who taught Rogier van der Weyden. When I measured it from the photograph, I realized right away that these were not the standard video proportions. Projection, being light, allowed me to vary the aspect ratio of the images, the vertical to horizontal proportions, and I designed a rear-projection system with light baffles behind the screens to mask off the unwanted areas of the picture.

The City of Man was the first time I used a nonstandard aspect ratio in my work, something that's been a part of the normal repertoire for painters. I mounted the projectors sideways to maximize the resolution, and this also created the strange quality of having the video scan lines run vertically instead of horizontally in the images. I even put wooden frames around the screens, something I probably wouldn't do today.

Looking back, what's very interesting about that piece is that it was coming out of landscape. It's the large-scale view, the place of man in the natural environment and in the cosmos—no close-ups, no central characters. It's on the scale of the society, not the individual. In this aspect *The City of Man* is more connected to *Going Forth By Day* than almost any other work of mine that references historical painting. The Berlin project also steps back to view the human condition on the scale of crowds and the masses. Even when people are depicted more intimately—in terms of the resurrection scene or in the little house in the boat voyage scene—they are still part of this landscape.

JH: It's interesting that, beginning with your work related to the triptych, both cinematic scale and architectural reference come into play for you.

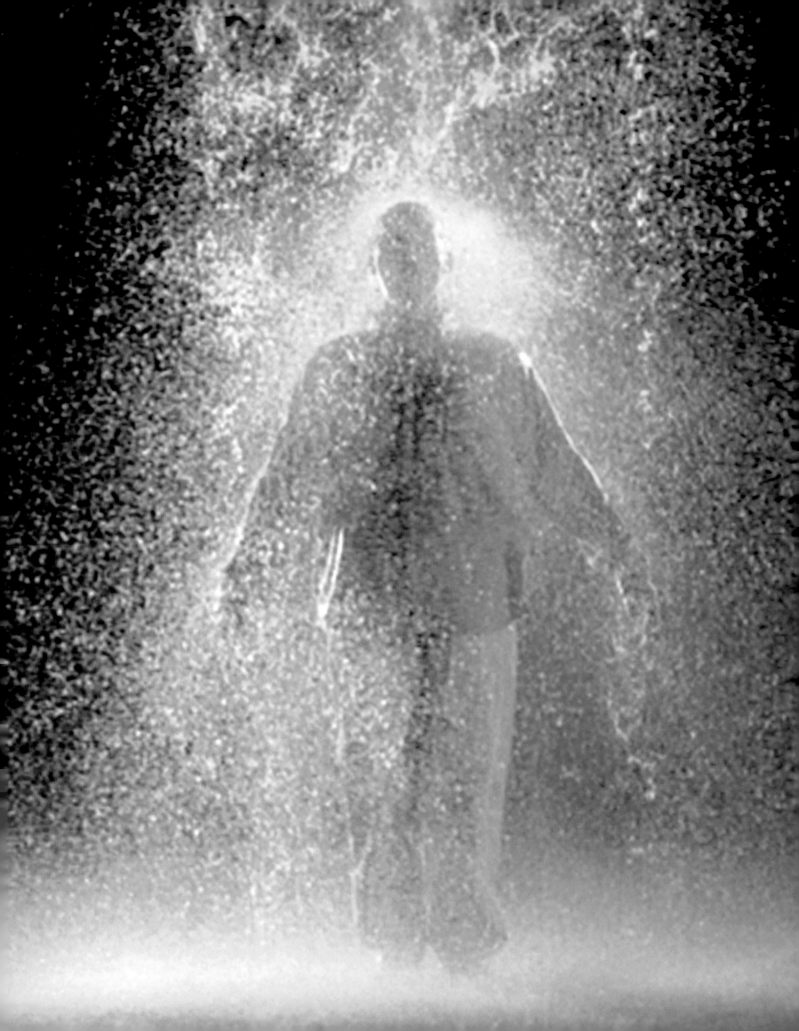

BV: Well, I think that the great hidden tradition in painting is time, and art historians miss it consistently—time and the unfolding of awareness. The movement of consciousness is the real subject of a lot of old master paintings. Even though they're imprisoned in the perpetual moment of the still image, the static object, they're all about movement. You've just been somewhere, and now you're taking the first step to the next place. At that moment of peak tension and transition, when time is turning over—bang!—that's where the artist puts the frame. And artists were completely aware of that, whether it's the last light slipping from the landscape or the fleeting glance of a person at a moment of realization.

When I see this, as a video artist, it only deepens my respect for the old masters—as it was practiced by those artists, painting had a Zen aspect to it. What if someone comes to you and says, "You only have one frame of the time flow to represent, so which one are you going to choose?" I have 54,000 frames in thirty minutes of video; they had one. And what better way to understand time? If you want to understand sight, blindfold yourself. If you want to understand time, stop moving. You have only one glimpse. The eye will open one time, and the whole world—everything that the moment has to convey—has to be contained in that one blink.

So, there is Mary in the Visitation—pregnant from an invisible father, just off the train from a long, tense journey to visit her sister in the countryside—distraught, afraid, seeking comfort. Arrived, approaching, awaiting the release of her sister's embrace. And what part of this action do they always show? The approach from a distance? Mary sinking into her sister's arms? No, the moment of greatest tension: the split second just *before* they touch. This is correct, and the whole exercise is very impressive.

Now, after years of working with video, I experience time as a palpable substance. It's the most real material that I know. I've learned to look at everything as a form of time, and this is not just in terms of technology. Those are only the tools, the current mechanical aids that allow you to see the world in a new way. Time has been at the nexus of spiritual discipline for a long time. Dogen Zenji—the great Japanese Buddhist master from the thirteenth century who revo-lutionized Zen practice in Japan—would demand of his followers, "See yourself, and all things, as a moment in time." And, "The way the self arrays itself is the form of the whole world."

He's talking about an intangible essence—the flowing of the river, not the water—yet it has an existence. That's why I could look at frescoes and see a movie, and look at old master paintings and see the dynamic of time being expressed. I am convinced that the generations of young people growing up with current and future media tools will regard this as the fundamental basis for their world. If you break the vise grip that literature has on narrative and open it out into the world of direct experience, you see narrative as a time form. Aristotle's classic structure of "introduction, crisis, resolution" becomes a wave shape from nature, not necessarily the form of a text.

JH: You know, the art world is sort of at the end point of the Duchampian moment. The idea of aesthetics as tradition, of beauty as an ideal, is not resonant in much of the art world. Yet it is very resonant in your work, as is the idea of emotion. Significantly, emotion is now coming into philosophy and cognitive studies in a powerful way in the writings of Antonio Damasio and others. And in the art world I don't think the connection has been effectively made about how important emotion is to all of your work, particularly how important it is to this new work.

JH: What makes you unique, what makes your contribution so central to our art today is that you're tackling the issues of emotion, of feeling. You're tackling the issues of aesthetics, and you're not simply *quoting* the past—the past is informing you. It's not one past, not only a European past, but it's also China, Asia, Africa. Essentially, when you feel the cosmology above you in the desert—Death Valley, the Bonneville Salt Flats, Chott el-Djerid in Tunisia—you're spreading your arms in the archives of world culture. It's beating upon you, and you transform it through your understanding of video, of the moving image, and your embrace of digital forms of image making, where you can fashion and bring together video, film, cinema—the works. You create a new representation through your mind as a camera obscura, filtering information toward a new image on the wall. And this is grand, very powerful, very compelling.

BV: Well, I don't know how to respond to that, so let me talk about a related point. One of the techniques or mechanisms for all traditional systems of spiritual discipline is the transformation of perception, modifying the senses to create new knowledge and a deeper understanding. The European way to go at it is through headwork: study this, debate that, categorize, discard, consolidate, revise, come to conclusions, etc.—all done in a mode removed from direct perception. The Eastern way, generally speaking, has been to go through the body. Even though there is a common thread in most of these traditions that categorizes the senses as the source of illusion, they don't discard them; they go right into them to learn their language and uncover their lies. Then, they set out to retrain them and reinstruct the individual in their proper use. This part is called spiritual "practice."

The genius of the authors of the Upanishads—one of the oldest and most fundamental texts of the self-knowledge tradition from India—was to turn the gaze of the knower back onto himself so he could "know the knower." Once this is accomplished—and few rarely get there—then all experiences become pathways to learning and deepening, and knowledge becomes not the acquisition of facts but a living process.

With my work I wanted other people to experience some of the things I was experiencing. For example, quite by accident I discovered that individual raindrops contained miniature images of the space all around. Then, I created *He Weeps for You* [1976], an installation—with a live video camera, a close-up lens, and a large-screen projector—configured in such a way as to allow the viewer the opportunity to make this same discovery. I also wanted other people to have the experience of being out in the huge spaces of the desert in Death Valley, where I had this massive realization and revelation about space, perception, and the Self. But I didn't want to describe it to them. That's one of the limitations of the Western system too, this incessant description, as if identifying or naming something was a way to understand It. I wanted them to *have* the experience.

If you're going after the experience, you don't go after the literal description of the thing. If you want to put someone out in Death Valley, and we're in a room in New York City in some museum, you turn out the lights. You don't show pictures of the desert on the wall. You know what I mean? You do something to them viscerally, physically, perceptually that puts them in that state. You speak in the language of the experience itself, in the present tense. This is about Being, not appearances.

JH: Was the installation *Room for St. John of the Cross* [1983] a model of that?

BV: Yes, both in terms of subject matter and the way the piece was constructed. In 1982 I picked up a New Directions paperback of the poems of Saint John of the Cross. I was so taken not only by his poetry but also by the ordeal of his life, described so beautifully by Willis Barnstone in his introduction to the book, itself a great piece of writing. Saint John composed such soaring and deeply spiritual poetry while being imprisoned and tortured by the Inquisition in 1577. He devoted himself to what he called the "via Negativa," epitomized by the passage through the "dark night of the soul," where the individual falls into a state of unknowing at the very edge of experience, far beyond the boundaries of conventional knowledge.

What I did was to construct a room within a room—a small black cubicle representing not only Saint John's prison cell but also the prison of our own bodies—and placed it in a larger room, also painted black. The viewer is simultaneously inside and outside the piece. And I projected violently moving images of snow-covered mountains on a large screen on the back wall, behind the cubicle, along with the sound of loud roaring and rumbling. The effect was that of a huge storm with a calm center: the cubicle with soft light and the sound of a voice whispering Saint John's poems emerging from inside.

Personally, I had been deeply moved by reading this man's poems and hearing the story of his life. The idea for the work was born from this and took on a life of its own. I saw that these ideas had literally changed my life, and therefore I thought that possibly this could change someone else's life too. Again, I didn't want to do this literally, as a description.

After reading these and other spiritual texts from the great traditions, at times with great difficulty, I finally realized that the ultimate aim here is not whether you understood the text, but if you were transformed. You know, right to the very core of your being. That puts a whole other dimension into the practice of making art. The literary criticism/aesthetic part of Saint John's work became secondary.

Then, after returning from living in Japan in the early 1980s, I found myself spending more and more time with traditional art forms, from both East and West. I'll never forget an experience I had in Tokyo seeing an exhibition of art treasures from a temple in Nara at the Suntory Museum of Art. A row of life-size Bodhisattva figures stood in the gallery, and I was dutifully reading my English guidebook to edify my art historical appreciation of them. Then, a little old lady went down the row, bowing low with hands together before each one and placing a silk prayer scarf on their extended arms. I realized at that moment that while I was analyzing them, she was *using* them. [Laughs] It felt like up until that point my viewing of these works had been like looking at a computer sitting on a polished table and admiring its design and shape without ever turning it on. This

is probably one of the things that really overpowered me as I went forward and was forced to put my art training in perspective.

JH: I would like to go back to discussing time, and the slowing down of representational time, for want of a better term. In *The Greeting*, for example, art historical reference becomes something other than that; it becomes the construction of a theater of memory. The embracing gestures, the furl of the clothing, the darkness of the architectural passageway—all become time.

BV: Well, just as in architecture where absolute scale, the notion of what's "big" and "small," is referenced to the human body, time is also judged by our bodies, by heartbeats and life spans. Just as there are feet and inches—and both are measurements derived from the human body—there is the heartbeat that, averaging about sixty beats a minute, is the standard for a primary increment of time: the second.

Therefore, what's perceived as being "fast" or "slow" is also a relative judgment. The interesting thing is that we—our conscious, perceiving minds—operate within a specific time window. There are things that happen too fast for us to perceive, such as a bullet fired from a gun, or too slow, such as the erosion of a stone by dripping water. Compounding this is the fact that the passage of time is not a sensory phenomenon. We witness its effects, experience it in terms of space and movement. We know if we are late or early. We are deceived by the clock—we believe that time is composed of identical units that are the same midday or midnight, but this is just the function of a mechanical device. Our experience tells us otherwise. We cannot actually see, touch, taste, hear, or smell time itself.

So, I realized that a lot of the struggle I was having was how to make time palpable and real. From an artistic perspective, time had to be made malleable. The dilemma was that my visual arts training gave me nothing in terms of how to solve this problem. And I think this is still a big problem today; young people see images as living in the flow of time while the education system regards them as static objects. Turning to the narrative filmmaking tradition was not an option either. It was too conventional and limiting for my purposes.

In the end, I looked to music, because that's exactly what musicians and composers have to do: make time palpable. I had taken classes in electronic music in the music school at university, and working with electronic circuits and synthesizers helped me greatly to grasp the intangible world of vibrating electrons and signal processing. I approached this work as an artist, not strictly as a musician, and was able see these elements as my basic materials. Nam June Paik, whom I first met while still in school, was my mentor and model for this; I understood the deep connection to music in his video work. Also at this time, the mid-1970s, I had begun to work with the composer David Tudor, performing his piece *Rainforest* with a group of young avant-garde composers. This was probably the greatest experience I had in terms of opening up my eyes and ears to the invisible world of sound.

Once this world opened up, I saw that many, many forms of time exist—even at this very moment. We have a paucity of language when speaking of time, just as we have for the term "soul." With these, we have one word for something that is so enormous and intricate. There's a massive amount of stuff inside a human being, psychologically, spiritually. We have been slowing down, speeding up, and expanding time since we have been on this earth as a species. There are specific techniques for this in many cultures, from Indian Yoga to Siberian shamanism. Out-of-body experiences, seeing at a distance (or telepathy), premonitions, déjà vu—all these things are a natural part of our heritage as human beings. They have been described and well documented and are part of every culture on the planet. But before the advent of new electronic/digital media in the last century, these aspects did not have a technological representation or artificial manifestation. Now they have been made into tools—the way spear-throwers and axes were—and this is a very important development for humanity.

Once you start slowing down time, which these media tools allow us to do, you automatically have crossed a threshold, departing from the physical world and entering the metaphysical world. Because the only place apart from technology that it's possible to slow down time is in the human mind. When I alter time in the editing room, it automatically locates the image in the domain of subjective perception, a kind of mental imagery, not optical imagery. It's an altered state basically, and it's very tied to memory, as you brought up, John.

Memories linger in the mind; moments continue to unfold in our thoughts. To this day I can still see my mother eating a banana split when we were out shopping one day when I was a little boy. It's like slow motion. I wouldn't exactly call it literal slow motion, but I would call it a form of slow motion, the way it lingers in my mind. It plays in a loop, while the actual experience was just—whoosh!—it went by like that.

JH: How does time relate to space?

BV: Well, it's integrally related. That was what the late-nineteenth-century, early-twentieth-century revolution in physics was about: the realization that they are the same material. But the thing that most dramatically altered our conscious existence in the twentieth century was the collapse of time and space in the form of communications technology. You can make a phone call to Paris and speak to someone there at this very moment. Never before in the history of humanity has someone who is at a distant place been immediately accessible to you.

JH: Real-time accessibility.

BV: Yes, yes, the idea that this moment exists simultaneously on earth in two different places. This was never a reality; it could only be a concept, and it wasn't necessarily apparent. This is because it always took time to get to the place where the other person was, so an instantaneous contact could never happen. If it did occur, it was classified as a vision or a supernatural event. Now we make a cell phone call from the Arizona desert to downtown Tokyo without thinking about it.

JH: Your installations are meditations on time and space.

BV: Yes, they are, and our entire technological culture is becoming a meditation on time and space.

JH: How is time represented in the frescoes that interest you?

BV: Well, first of all, the subject matter of these artists was eternal and sacred. And herein lies the great conflict as well as the artistic problem to be solved: How do you represent eternal time within the confines of the chronological time that we inhabit and have learned to represent? One could argue that the reason why stone is the primary traditional material of sculpture, and why people needed to create a painted image or likeness for that matter, lies in this desire to transcend the limitations of our mortal bodies and live in eternity. One definition of eternal life is existence outside of time.

The first mechanical clocks were coming into being around the time Giotto was painting. A new kind of time was being identified simply by the existence of this new measuring device, and it was not the common time of agrarian cycles and natural light.

JH: Time was measured differently.

BV: And this changed our experience of it. These new clocks were being installed in the public spaces of the churches, right at the religious and social nodal point. Paolo Uccello's famous clock in Florence was created in the early 1400s, just as humanism was being born. What the Christian tradition did, which turned out to be so powerful for the Italians in the fifteenth century, was to put the eternal acts of sacred beings in a familiar space, *our* space and time. We all know that as mere mortals we are destined to be born and to die. The gods, however, are eternal, existing in some transdimensional, entirely other space. The Christians took this whole tradition of the separate divine realm, going back to the Egyptians and the Greeks, and brought it right down to earth in their declaration that Jesus Christ is no mere prophet but the son of God himself.

Then, along comes optics and a mode of visual representation based on how the eye sees things, not on how the heart feels them. Once you're in the domain of optics, you're in the domain of time. To experience the painting that Brunelleschi created in his famous demonstration of perspective at the baptistery in front of the Cathedral of Florence in 1425, and to see it all perfectly line up—painting and object—was a demonstration of the representation of time as much as it was space.

The real power of optical art lies in the fact that time changes. You're looking at an older portrait of the king, and you see that now he's an old man. In an age before photography you would say, "I never saw that so clearly before." Here is the optical image showing us something that's been invisible, and it gets even more powerful when the person has died. Then, add to this the fact that in the images of the Christian tradition from the Renaissance onward these people look just like us. They're sacred and holy—gods in a way—but they look and act as we do. They live in a world that looks like ours, with houses, streets, carts, trees, sky, clouds. And they even die like us: the Deposition, the Assumption of the Virgin. That's pretty shocking but also reassuring. The gods are in our world; they've fallen into our world, into the temporal world.

Then, along comes Giotto, and he brings emotion into it—fragile, fleeting human emotion. He overturned the whole Byzantine tradition of the solemn medieval Madonnas. The reason why they are so poker-faced and still is because they're eternal. This was the Western Christian image tradition of "imago," the depiction of eternal Being, not appearance. The emotion is in you, the spectator, not in the image. And Giotto turned that mirror around: all of a sudden, the angels are crying and contorting in the sky when Christ dies. People must have been stunned to see that, to see a temporal, worldly event in Heaven, to see the reaction as tears roll down cheeks in agonized sorrow.

JH: What do you want people to see in a work like *The Greeting*, and how does it relate to narrative?

BV: *The Greeting* was an uncomfortable step for me, in a way, because it is a narrative. It's based on a time event that has a beginning, middle, and end. There's a beginning, two ladies talking and nothing much is going on. And you can see these little figures in the background, in a doorway, doing something. Then a crisis is reached when a woman arrives out of the blue, from off camera, and greets one of the two women. That changes the whole situation. And then

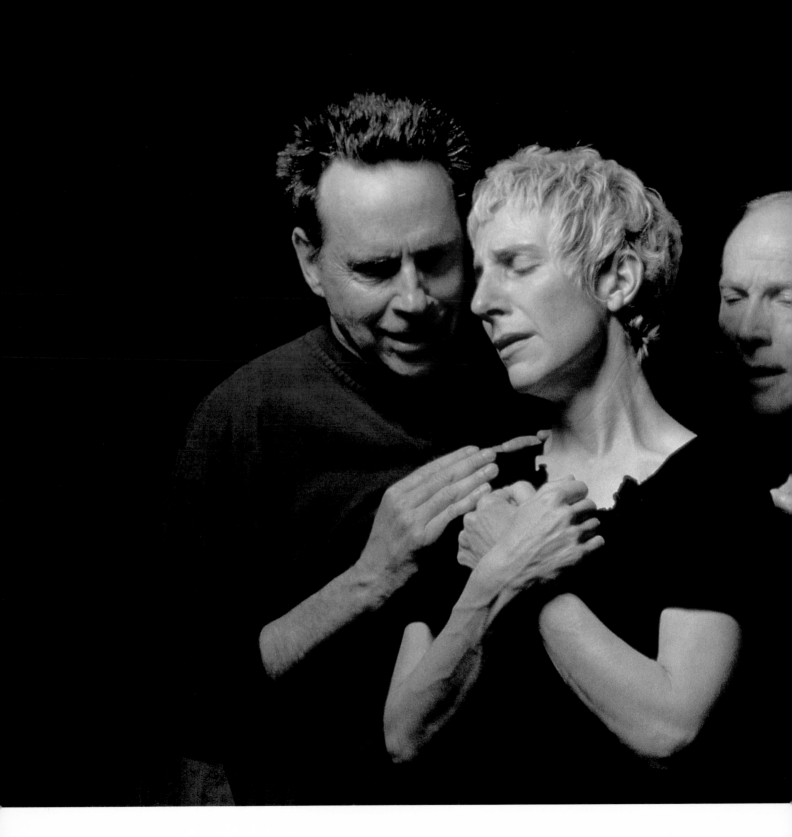

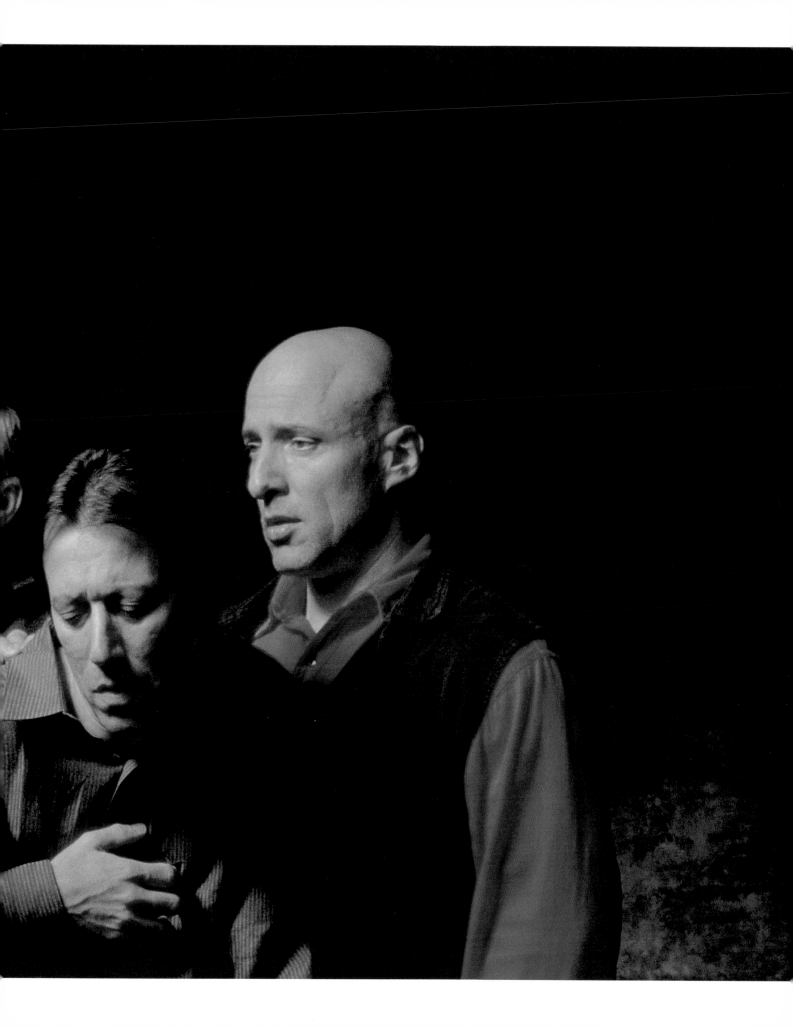

there's the aftermath of that, where the situation—altered by this one striking event—now has to readjust and reaccommodate to the shift. That's classic narrative structure.

JH: That's what I'm interested in, this idea that it's a narrative structure. It involves people, emotion, and place.

BV: Well, human emotion is, of course, the archetypal expression of the fragility of time. We even link the words together in English: "fleeting emotions." The beauty of the emotions is the fact that you don't have a smile on your face twenty-four hours a day. Constant unchanging emotional expression is unnatural and even can be an indication of pathological behavior. Emotions are the manifestation of time in human consciousness, as exhibited on its outer surface.

JH: In *Going Forth By Day* the issue of emotion as a moment—emotion as time—becomes a foregrounding force. Time shapes your image, and the image shapes time because of its deliberateness. Your time is like a series of frozen moments that become a seamless continuity, so that emotion becomes really powerful. You use narrative and the figurative form to represent emotion. Working with the figure in terms of the performer or actor, you have to take on a whole other relationship. You have to construct it; the human form is now not just something you discovered on the horizon. You have to direct a person, engage them. What is that like? How did you go about it and make that transition?

BV: Well, looking back, a turning point for me with emotion is a piece I did in 1987 called *Passage*. It was very simple, two handheld cameras recording a four-year-old's birthday party. Knowing in advance that it was going to be slowed down in time, I instructed the camera people to shoot it like a football game: keep moving, panning, zooming in, zooming out. I edited three hours of material down to twenty-six minutes, which, for me, was going against the grain because I had to cut it very quickly and make the montage very dense.

Again, the revelation came through the subject matter. I had these kids, four-year-olds, one of the most magical ages in life. Consciousness is being formed. You're not an infant anymore. You can control your bodily functions. You can pick up a cup and drink without spilling it. You're transitioning into becoming an autonomous being, but the world is still magical and wondrous. A birthday party can be one of the most vivid memories we all have: the colored balloons, the cake with the glowing candles, the singing. It's a contemporary ritual.

And the faces. There are a lot of close-ups in the piece, faces filled with pure wonder: staring at the candle flame, seeing the world through a purple balloon, tasting the colored decorations on the cake. It was a special privilege to record those images, the small miracles that happen every day. And the thing that impressed me the most was to see that when joy bursts onto a four-year-old's face as the birthday cake comes out or when the tears come after a fall on the hard floor, these are such brief moments. With kids you can see the feelings arrive and depart in a split second; they don't last.

When all of this is slowed down to sixteen percent of its normal speed, those two seconds of a burst of emotion are now thirty-two seconds, unfolding and opening like a flower. The slowing down of the image was a technical exercise with intentional results. I knew that the physical actions would be extended in time a finite amount, but I was unprepared for the fact that the emotions just kept going right along with the actions, at times even exceeding them.

In the editing room, experimenting with playback speeds, I would slow the images way, way down, sometimes pausing them for long periods as still pictures. At that point, coming in through the back door of the moving image, I arrived at photography. In that still image, an eternal frame, the emotions remained there, continuing to unfold in time. At that moment I realized that even though emotions are temporal, they're also infinite. They exist outside of linear time. That was a profound realization, but I didn't really follow up on it until I had traversed the chasm of my mother's death a few years later and deepened my interest in old master painting after that.

And that was part of the background that led me in the 1990s to start working more directly with performers. Again, this was another big step. I was no longer in front of the camera, my comfort zone in

making video work. Now someone else was there. When it's yourself in front of the camera, you don't have to tell anybody what to do; you just do it. That was a very difficult transition for me, to direct other people. Other than with very physical performances, the first time I really used actors was in *The Greeting*; that was really my first experience in directing. Bonnie Snyder, who plays the older woman, is an actor who had worked with Cassavetes, so these were people with experience.

JH: How did that feel, working with actors?

BV: It was really strange. It made me very uncomfortable. I mean, I don't like telling people what to do. For me the ideal state is when everybody just has the inner awareness to do something, and it's correct for everybody at that moment. [Laughs] That's why I've always been drawn to what is called documentary or vérité filmmaking, where reality is ongoing and the camera allows you to ride that breaking wave without trying to control it.

JH: Was that still happening in *The Greeting*?

BV: To some extent, yes, because I really didn't micromanage the actors. I set the parameters and allowed them to improvise.

JH: But I sensed at your studio when you were preparing the resurrection scene, one of the five image sequences of *Going Forth By Day*, that you are rehearsing and thinking about the form, that every detail is something you're controlling.

BV: Let me put it this way, every detail passes before my conscious mind. Whether I control it or not is the next decision. But the bottom line is that it's all being consciously perceived.

JH: The position of the body, the arms, the way the head is tilted.

BV: And the drips of water.

JH: Was that happening in preparing *The Crossing* [1996] too?

BV: In a certain way, yes. The key point is that when you're dealing with recording media, you're involved with the transition from unconscious to conscious. Students often have difficulty in perceiving this aspect of the form when they're just starting out. Whether it's film or video, you're working with an instrument, the camera, which is an instrument of conscious perception. It reveals unconscious behavior to us by making that behavior conscious through the act of recording and viewing it. This is why it's been used for this purpose in many psychological studies. So whether you are aware of it or not, your main work as a film/videomaker lies in working with the unconscious areas of our lives. The medium is an awareness amplifier.

JH: You mean the medium of video?

BV: Well, film or video, but video perhaps more so because it has the added dimension of real time; its moving image coexists with the actions, live. When I go to shoot something, I have to train myself to be aware of all of the elements that are normally unconscious to me, which are actually the majority of one's experience at any given moment. My Zen training has helped with this to some extent.

This is also why actors need to act unconsciously while performing, "inhabiting" their character to such an extent that any gestures or actions they exhibit, planned or not, are correct because within the frame of their character, the person they've become would have done it that way. If the behavior is perceived to be conscious or too deliberate, then we describe it as "bad acting."

JH: You made references in *Passage* to the everyday. I mean, a birthday party is a special occasion, but it's still a familiar, everyday experience. But *Going Forth By Day*, as with much of your recent work, has different kinds of cultural references, whether a Chinese wedding boat, a fresco, or a Noh drama. They're going through another filter of your consciousness of reference, and you're creating mise-en-scènes that are referring to other mise-en-scènes. This is very different from the birthday party and the everyday.

BV: Yes, it's completely different.

JH: How does that come about?

BV: I have to answer by just saying that it's connected to my process of aging and growing and maturing.

JH: The references mean that you can control things and can create theater. Isn't that part of it? Isn't there a different level of control that you're able to exercise? Where does the emotion come in?

BV: Well, let's take this discussion a little bit away from the issue of control. Earlier, I would go out and take the lens cover off the camera, and whatever was going on I would capture. Then, of course, in the editing room I would select this or that and reshape the material in a specific way. This is similar to a sculptor going out and finding objects from nature to work with. And the images in the end function in exactly the same way as in traditional representational painting, in the sense that whatever you see on the screen was deliberately put there, even though I didn't create the actual situation. It was not something that I was originally controlling per se.

Nonetheless, I've always been fighting with this issue of control versus noncontrol. Starting with *The Greeting* in 1995, the reference point was not just the flow of reality itself; now there was the entire scene—the street, the architecture, time of day, and especially this meticulous arena of people's deliberate actions—to compose. And so I find that I'm taking this new process as a base point and as a touchstone to go off into . . . I don't know what. I can't articulate it clearly to myself. But this fact is an interesting thing in and of itself, you know. Clearly, like you mentioned, the works are not just quotes. They are not merely exercises in restaging or appropriation, and they're not movies either. Yet they are linked to something that other historical artists have done.

JH: Just now, I was looking over at your books and seeing the works of Georges de la Tour, with his paintings that depicted the everyday—to get back to that. In the recent work that you have been creating for the flat screen, including *The Quintet of the Astonished* [2000] and *Going Forth By Day*, do you see the everyday embedded in the gestures of emotions and feelings?

BV: I would answer no, because the everyday is content: you're crying because your wife left you; you're crying because your mother passed away; you're crying because your best friend is gravely ill. The pieces that I've been doing with these digital flat screens are contentless. They are in the tradition of imago, of image making where the subjects act as projection screens for the viewer's inner state.

JH: But all the work you've been referring to has been about content.

BV: Well, it has, it has.

JH: Christian content?

BV: Perhaps in an expanded sense, yes. Since the time I lived in Japan, I found many deep connections to a culture that was so distant from my own, and since that time I've sought to uncover the underground root structures of various cultures in our lives, particularly in regard to the spiritual life. The spiritual is in many ways, by definition, a vast underground river that moves in darkness and silence below the surface of our daily life. It is like a deep natural spring that I draw from over and over in my life now, and this source includes the Western Christian tradition of my own culture, which contains at its roots, beneath the politics and complicated history, some profound spiritual elements.

There are two people in a diptych in my piece *Dolorosa* [2000], a man and a woman bound together, their images physically attached, like in a medieval hinged devotional panel painting. Conventionally, it is two "head-and-shoulders" portraits, shot on 35mm film so the lighting and picture quality look like a traditional photograph—but here shown digitally on flat screens, and it's moving, unfolding in slow motion. The people are crying, although you have no idea why. There is no story here. The story, *you* bring the story, which is exactly what was going on with the Madonnas in the Byzantine tradition up until the Renaissance brought them to life as individuals in the picture frame.

JH: But there is a story; we understand why they are both crying. The emotion was the death of Christ.

BV: Yes, but it was seen within a culture that didn't take things literally, that understood the power of metaphor, that lived by the life force of myth and symbolism.

JH: So, in this diptych it's the metaphor that you've made?

BV: Well, it's going back to that. It's trying to break the stranglehold—

JH: Of metaphor?

BV: —of literal representation. This is the danger point of the optical medium. Once you give the image-making process over to optics, you're automatically bound to the representation of the content, literally, visually. This was the great problem that the Italians had with the work of Flemish painters in the fifteenth century, when the optical method was the latest, most advanced technology.

The Italians couldn't let go of what they called *fantasia*, the world not as the eye sees it but how the heart feels it. The Northerners had a much cooler, more clinical gaze, the view that was to become the dream of the Protestant merchant class: to see a reflection of themselves in every pearl. Although I love the work, sometimes I can't bear to look at those pictures by Rogier van der Weyden, Hans Memling, Gerard David, and their later followers. There is so much suffering there; it's what happens when you take on the material world head-on.

They had this new medium and technique—oil paint—the most sophisticated imaging system on the planet at the time, the equivalent of digital high-definition video today. It could show you the weave in the fabric, every little glint of light, every polished link on a gold necklace, every oozing pustule on the crucified Christ's skin. They went after that, like some kind of spartan ideal, and the pain and suffering is there in every brushstroke.

The Italians recognized that the material world was the new focus, and they pioneered the technical means to bring their forms out of the two-dimensional plane of the picture, moving painting closer to the world of sculpture. But it was still the *fantasia* of emotion that concerned them—the energy feeling of these things was so strong for them. *This* was the realism they were after. You can still see it clearly today in the straining to make the figures move, to make them come to life.

JH: As the artist, you're asking actors to evince the emotion. How do you draw out the emotion that you want to see represented?

BV: Well, with *The Greeting*, for example, I really wanted to deal with the essence of the nature of the social situation, not deal with a story at all. Two women are talking, and they're interrupted by a third, and you see the social dynamic shift. You see discomfort and awkwardness when they don't know each other. I was really fascinated with that kind of substructure.

The same thing happens when you're sitting in an airport, and you look over to see two people meeting after one of them has gotten off a plane. You get a little reading of the social dynamics of that situation. It's complex and very fascinating. I was interested in that in an almost sculptural way, so I wanted to set up a situation that would create those kinds of dynamics. And I knew from experience that slow motion could actually make visible the events that were unconscious and could bring those things right up front, which is ultimately what I was after.

I get on the set, meet these actors, and we begin to work on the scene. And they immediately want to know, "What's the story? Who is my character? What is her motivation?" Meanwhile, I was trying to get them to step outside that kind of container and think in a more open way. So, with advice and assistance from my production coordinator, we gave the characters names and wrote up a background sketch on each one, along with a general treatment of the action. I couldn't believe I was doing this, since my focus was on much broader issues. Suddenly, there was a story there, and everyone felt comfortable except me.

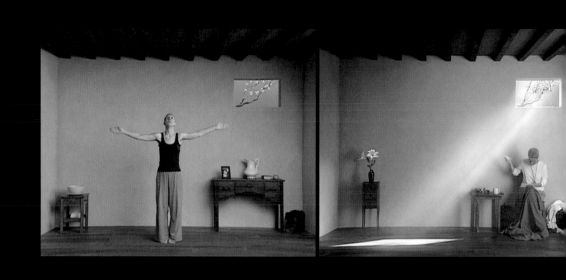

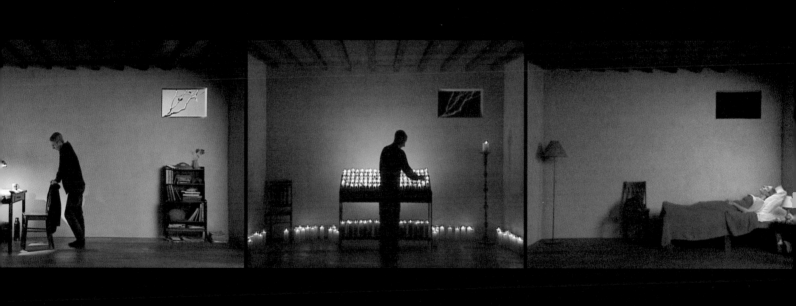

Previously, I used to go out into the world, into the landscape, to find the right shot. I would search for exactly the right hill to put my camera on and wait for the light and the clouds and the trees and the bison to be just right out there in the Black Hills of South Dakota in May 1984. I did this many times. It was uncanny, wandering aimlessly, sometimes for days, going on some vague feeling, and then I'd sense it was getting close and watch, almost miraculously, as the elements in the landscape configured themselves into the image I saw in my mind. It was as affirming as déjà vu, but always the stage had been set long before I arrived.

I then saw that what I was doing with *The Greeting* was very similar to that earlier landscape work. But instead of walking out in the Black Hills with an internal image, I had to create the entire context behind the scene by spending the time—again following vague sensations—to design the details of the set and the light and give the actors all this background information. When the audience sees it on the screen, without dialogue and plot, the story and details don't overtly exist; it's implicit in the women's actions, their body language and unconscious gestures.

And that was really interesting, that I had to build these highly detailed hidden layers in order to have the overview of the situation be successful and open-ended. It is intimate and very familiar, but in a way it's the distant view that allows the emotions to take on a life of their own within the viewer. You vividly experience the emotional arc and inner landscape of what goes on with these women, but you don't get bogged down with "this is so-and-so, and her boyfriend just did blah-blah-blah," like in the movies. You're seeing things as a child would perceive them: Mom and Dad are arguing and the kid is frightened and upset, stomach in a knot, but he hasn't got a clue that it's about the rent check that never got mailed.

This is actually more how we experience the world the majority of the time, when we venture out of our homes and enter the social flow of daily life. It is the invisible world of all the details of people's personal lives—their desires, conflicts, motivations—that is hidden from our view and creates the intricate and seemingly infinite web of shifting relations that meets the eye. The real energy always comes from invisible things, and that's where I want my camera to be, capturing the register of feelings, not the optical view. So that was a big learning experience for me, how to do that when I was the one responsible for defining all these unconscious layers and serendipitous circumstances.

JH: And now you're creating these extraordinary mise-en-scènes. Sometimes when I speak about your recent work to curators whose area takes them through the eighteenth century and no further—such as when I showed slides at the Hermitage about the media arts, including your recent work, and had a conversation with a curator of the Kunsthistorisches Museum Wien—the response is that this work is in dialogue with work in their collections, that it'd be interesting to show you and the old masters together.

Your great videotapes—*Hatsu-Yume (First Dream)* [1981], *The Passing* [1991], *I Do Not Know What It Is I Am Like* [1986]—are core works of late-twentieth-century art, and recently, *The Quintet of Remembrance* [2000] was acquired by the Metropolitan Museum of Art as the first work of moving image to be brought into the collection.

BV: It's time to die I guess. [Laughs]

JH: No, not yet! [Laughs] I think you are now at a profound turn in your career, a kind of synthesizing movement into another dimension of the imaginary end of art making.

EVENING

JH: You are taking your experience into a new dimension, and it's almost like it's coming full circle, connecting the great waves of pre-Modernism with Modernism. You came out of the late twentieth century, exposing—moving into and evoking—powerful feelings of emotion, narrative, subjectivity, aesthetics, and you're continuing this in a new body of work.

It's difficult to find the descriptive, analytical language to discuss it, but I think that this is your ultimate fusion of the moving image. It was very interesting when you said that you were getting away from the formal interpretation of content. Yet, in a way, your work has always been about content, and you are now pushing that content into this visual field of the digital, which is merely a way to identify it in terms of the technology. But what is imagistically possible through this is happening because your intelligence and your aesthetic is able to put it into another place.

BV: What I see happening with the digital revolution is that it is similar to other revolutions like radio, television, video, and certainly photography before them, but on another level it's very different. We can sense this without knowing the technical details because the digital revolution is a revolution of infrastructure. The changes being implemented by this new language cut across boundaries of disciplines, professional occupations and practices, and private life. The effects we are witnessing are so sweeping and fundamental because the digital medium itself bears more resemblance to the ground under our feet than it does to the familiar structures on it: the street, the trees, this house we are in.

It is so universal, a master code in a world that is increasingly based on codes. In this age it is technology—tool making—that is carrying the force and direction of the elemental striving of human beings for unity. At other times it was religion, philosophy, or metaphysics. Houston Smith, the great scholar of world religion, has said that the two primary forces that have had the most profound effect on our existence in all aspects are technology and revelation.

The power of science, from the Occident to the Orient, was to recognize that there could be a code or fundamental form underlying all things and to search for it, whether in the subatomic levels of the material world, in extreme interstellar space, or in the microscopic dimension of life itself. It is no coincidence that the computer revolution is occurring at the same time that the human genome project— decoding the genetic code that makes up a human being— is being realized.

A code is not something tangible; it's not a thing. The digital revolution is essentially the opening up of the unseen dimension, the articulation of the invisible world. So, here's a medium that itself is a code. And what is the function of a code? A code is something that can translate between two things. That's what codes do, and we are in the midst of another great age of translation, this time in a very different form.

JH: Video is no longer video; video and film are the same thing.

BV: *Every* visual form is the same thing. They have all been codified; it's as if the underlying language of things is being rewritten. Things that were previously disparate, such as balancing your checkbook, booking a flight, seeing dinosaurs come to life in a film, writing a novel, watching a baseball game, designing a car, diagnosing an illness from X-rays, deciphering the structure of the human body and modeling how far it's evolved—

JH: Fabricating resurrection.

BV: —fabricating resurrection, you name it—all are being linked by sharing the same underlying form. We are just at the beginning of seeing what can happen when these links are explored. I mean, this is an infrastructural change at the deepest level of society and culture and commerce. The scale is staggering. Perhaps some of the software is different, and there are incompatible hardware platforms, but it's the same basic instrument that's performing all these tasks. And it will become more similar. Already we are all playing the same music with the same scale of notes.

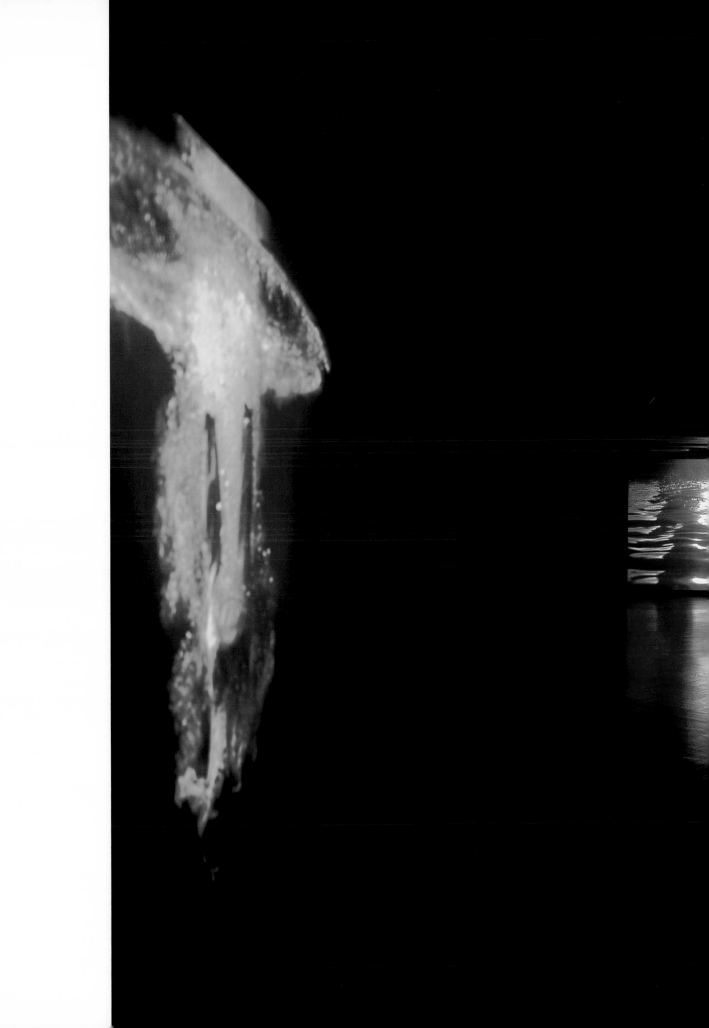

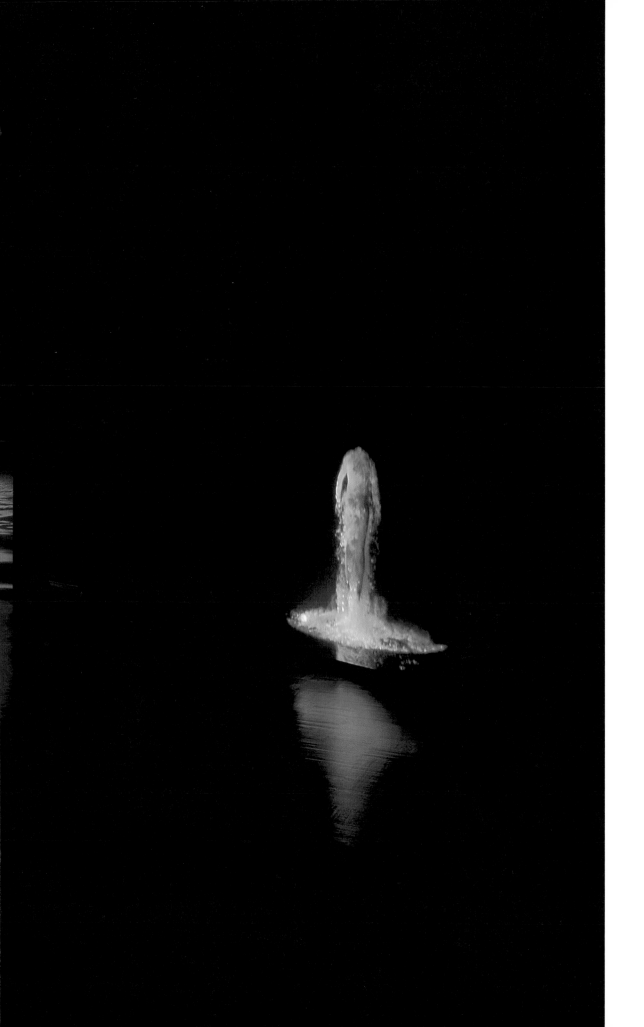

That is radically different from when television and cinema first entered into our world and became an important part of our daily life. They certainly weren't as deeply woven into the fabric of the society as digital technology is now. That's extremely powerful; there's never been anything really like it. Creatively, the possibilities are immense. Artists can now begin to take aspects of the culture that have never spoken to each other before and make them sing. Digital code is the DNA of visual culture. That's what's going on right now.

JH: You're *the artist* to be able to command it and give this DNA a direction, to fuse this enormous trajectory of Western and global culture.

BV: Wow, now it really is time to die or be killed in the process! [Laughs] I'm seeing a big landscape right now, and it's really overwhelming. For the first time I'm getting an inkling that I might not be able to complete all of what I can see in my lifetime. Such a giant world has opened up; it's exhilarating but humbling. I feel like there are no boundaries anymore—historically, stylistically, linguistically, culturally—only the limits of the imagination and a finite life span.

This interview took place five days before the tragic events of September 11, 2001. Many people will no doubt ask if the images in this work were created in response to those events. The answer is first no, and then yes. The Guggenheim Museum approached me with the idea of a commission for the Deutsche Bank space in Berlin in early 1998. The first image that came to my mind then is also the most distressing in light of the World Trade Center attacks—a building being flooded from within. For the next three years, I continued to develop ideas and research sources around the theme of the end of the world, but had difficulty encompassing the magnitude of the topic in one work. Things finally fell into place in the spring of this year.

The production was well under way when the planes struck the World Trade Center on September 11. A week after the tragedy, we were scheduled to begin rehearsals for the resurrection scene in panel five. Dan Gerrity, an actor with whom I had worked on several previous projects, jumped on a train from New York to Los Angeles so that he could be in the piece. He came filled with stories and powerful feelings that, along with the images we all had been seeing on TV, infused the work with a raw emotional energy and sense of purpose. Those terrible events have lent such a deep, cathartic power to the entire production process for all our team of technicians, artists and performers. The making of the piece became a mission and a source of strength for us all.

In the aftermath of September 11, the images that I had been working with began to take on a life of their own in the most haunting and yet reaffirming way—people fleeing from a flooded building, a team of exhausted rescue workers in the dawn light, a woman waiting for news of a lost loved one. I have always been aware how time collapses where works of art are concerned—how they can seem to exist outside of time in some other hidden dimension—but I had never experienced it first hand. For myself personally, the result has been that I have come to a deeper understanding of the nature and function of visions and prophecies and their relation to art making.

Several years ago I became drawn to the expression of human emotion in the encounter with final things on a large social scale. I became interested in the unifying role that terrible disasters and tragedies can play in a society and the effect that the human mind and the creative imagination can have on the origin and outcome of these forces. I researched the images of the

apocalypse in the Book of Revelation and how they have been visualized by artists. I discovered that the word "apocalypse" comes from the ancient Greek word *apokalypsis* which originally meant "the lifting of a veil" or "revelation." I revisited Dante's terrifying visions of the Inferno and Purgatorio, illuminated by Botticelli's delicate unfinished drawings. Finally, I went back to one of the root sources of humanity's concepts of the Underworld and the hereafter, the Egyptian Book of the Dead, with its exquisite painted images of the journey of the soul to the next world. The literal translation of the text's title from ancient Egyptian is "The Book of Going Forth by Day," the source of the title for this new piece.

But above all, the primary source of inspiration was the work of the Italian Renaissance master Luca Signorelli and his extraordinary and overwhelming vision of the end of the world in the Orvieto Cathedral fresco cycle of 1499–1504. I was fortunate to finally experience it in person on a visit to Italy last May. One panel shows a synoptic view of the various prophecies of the end of time—violent earthquakes, huge tidal waves, the torture of the innocent, the moon turning red, the sun black, the sky shimmering blood red, stars falling from the sky, and the heavenly onslaught—the demons sending down a rain of fire on the corrupted population of a world devoid of love or charity. In the lower left-hand corner of the picture, a crowd of people is fleeing in panic, trying to rush right out of the painting itself. Nearby, another panel consists entirely of a jumble of helpless, naked people, struggling as the demons torture and torment them, finally throwing them into the infernal fire.

Sacred texts are filled with terrifying images, most of them the result of human actions. Visits to museums that house artworks from the ages of religious tradition can be deeply disturbing and shocking. The airplanes that crashed into the World Trade Center towers pierced people's hearts, not just the two buildings. The experience for those who lived it, and the pictures that the rest of us have seen at a distance, will never be forgotten—such is the power of images now and at all times in the past. Media technology has amplified and accelerated the creation and dissemination of images in an unprecedented way, but their power to enter our hearts and minds, to embody and provoke our darkest fears and most exhalted visions, remains the same. Herein lies the importance of art, the value of history, and the social responsibility of image making, large and small, in contemporary society. In our time, there is an urgent necessity to have the creation of images be part of a true spiritual artistic practice and not merely a business profession.

The End of the World is an event that knows no boundaries in terms of scale, time, and place. It exists in events from the loss of a pet dog for the ten-year-old child to the loss of a beloved mother for the fifty-year-old parent. In fact, it encompasses loss on all scales—losing a favorite toy, a prized possession, a golden opportunity, a pocketful of cash, a job, a home, a friend, a faith. Losing a loved one to illness, losing a community to a flood or tornado, or losing an entire culture to the ravages of war and oppression. Innocent victims abound when the world comes to an end. Time strikes suddenly, accepting no excuses, delays or second chances.

A significant portion of my personal world came to an end three years ago when my father died. He had come to live out the remaining years of his life with my family in California but fell ill a few months later. All of his belongings that were shipped from his old house in Florida, awaiting a new home in our neighborhood, remained in the moving company's warehouse. He never recovered, and passed away a year later. My wife Kira, my brother Bob, and I were left with the task of unpacking the boxes and going through the contents of his house, which were laden with memories of our childhood. I dedicate the fourth panel in this work, "The Voyage," to his memory. I'd like to think that the unfinished act of his relocation is now complete and that he has journeyed well beyond the Isles of the Blessed to join my mother in a world where his material possessions are no longer needed.

Bill Viola
25 November 2001

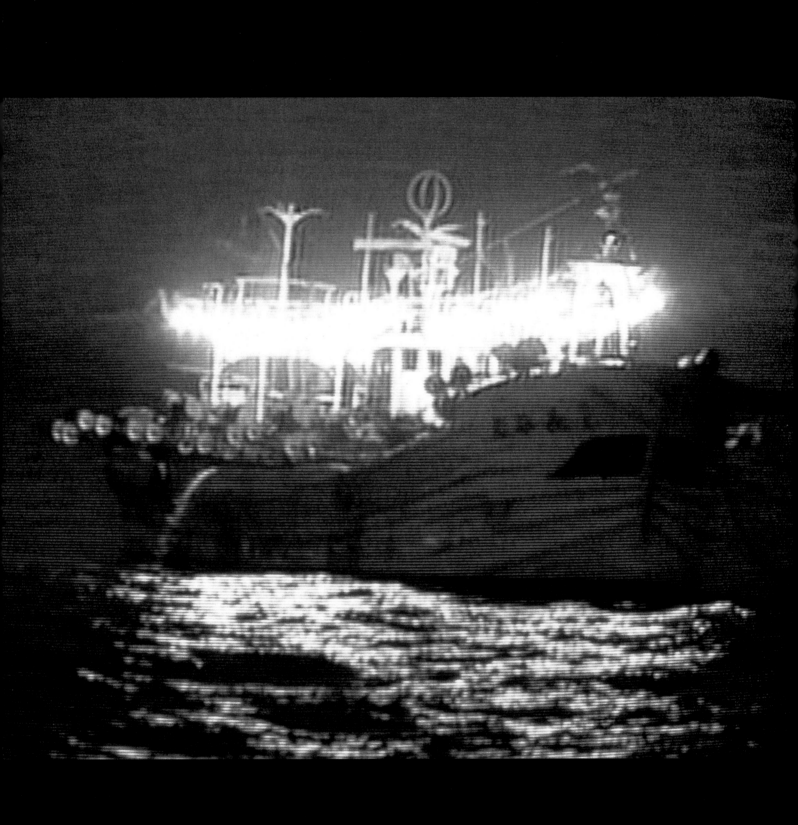

ACKNOWLEDGMENTS
BILL VIOLA

It is vital and important that artists are given the opportunity to create new work, and it is especially significant when the degree of support is such as to allow them to let their inspiration expand and extend out to a large scale. The program of the Deutsche Guggenheim Berlin commissions is such a project, and I am truly grateful to be asked to participate. I thank Director Thomas Krens and Deputy Director and Chief Curator Lisa Dennison of the New York Guggenheim, and especially Senior Curator of Film and Media Arts John G. Hanhardt, a long-time colleague in the field and curator of this exhibition. Associate Curator of Film and Media Arts Maria-Christina Villaseñor has been especially diligent in managing all the details of this complex project.

I also want to thank Deutsche Bank for providing the space and resources to produce and exhibit this work. I appreciate the support of Dr. Rolf-E. Breuer, Spokesman for the Board of Managing Directors, as well as the curators of the Deutsche Bank Collection, Dr. Ariane Grigoteit and Friedhelm Hütte. My thanks also go to the people at the Deutsche Guggenheim Berlin who have worked on this exhibition, Gallery Manager Svenja Simon and Sara Bernshausen.

I especially want to express my gratitude to Anthony d'Offay and James Cohan and their galleries, who generously supported the work when it became apparent that its scale and scope was going to far exceed our original estimates. This project culminates a decade of meaningful and fruitful work together, and I value our accomplishments and special relationship greatly.

Kira Perov, the Executive Producer of the project and my wife and partner, worked with a tenacity, stamina and deep caring to oversee all the main elements of the production and exhibition, as well as the editorial direction and preparation of materials for the two publications. Her unrelenting quest for quality and accuracy is an inspiration to us all. As always in our 24 years of working together, her creative and practical insights have proved essential to me in the creation of this work.

In our office, Bookkeeper Marie Slaton managed a literal flood of paper-work associated with the largest production we have ever undertaken. Traci Furan and Ann Do helped with exhibition logistics and catalogue material preparation. Designer Rebeca Méndez created a beautiful book, our second project together, and I thank her and Snow Kahn for their exquisite work.

A work of this scale and scope demands the creative resources of many talented individuals who must all function in concert with a unified vision. Our exceptional production team of over 130 people worked with a high level of craft, devotion to their work, and an impressive singular intensity to help create the images you see here. They should all be proud, as I am, of their formidable expertise and contributions. I thank them all. A few people deserve special mention: Bettina Jablonski, my Studio and Exhibitions Manager of many years, was in charge of the technical hardware and installation of the work. She worked long hours with

characteristic focus and relentless attention to detail to make sure the work would be presented at the highest quality. Her professional skills allowed me to devote most of my time to the all-consuming production process, secure in the knowledge that the final presentation was in her capable hands. She was assisted by Kimberli Meyer, Studio Project Manager, who also helped with the architectural drawings and design details for some of the sets.

S. Tobin Kirk, Producer, pulled together a massive production involving four unique and complex individual pieces arrayed within a labyrinth of logistics and severe time pressure. His energy and impressive experience guided us, and his tireless sense of humor kept us all light on our feet. The team of assistant managers that Tobin assembled, Genevieve Anderson, Bill Turner, Josh Lawson, and Chad Bickley, were exceptionally capable and positive.

I want to especially thank Harry Dawson, Director of Photography, for his sensitive eye and mastery of light. I value our close relationship, developed by working together on many of my large projects over the past decade. His devotion and contributions to this project are greater than any gift, and the computer-programmed sunrise in real time that he created for "First Light" was one of the highlights of our years of work together.

Wendy Samuels, our Production Designer, worked with great passion and personal commitment. She was able to decipher my "creative cloud" with patience and expediency, and she rose to the challenge of my demand for detail in the sets that even the High-Definition camera couldn't see. It was a real personal pleasure working with her, Art Director Timothy Thomas, Lead Scenic Lisa Watson and their outstanding team of scenic artists.

Brian Garbellini, long time Assistant Cameraman for Harry Dawson and myself, spent long hours bringing his focused meticulous attention to ensure the cameras and lenses were functioning properly, especially on the unprecedented HD three-camera panorama shoot for "The Path."

On the performance side, I want to express my deepest gratitude and respect for the actors who gave so much of themselves to express the subtlest layers of nuance and emotion in the scenes, without the help of either dialogue or close-ups. They played a big role in shaping their characters in terms of performance and action. Some are long-term collaborators, while for others this was our first work together. In all cases, their honest and complete entry into the inner nature of the work made the pieces become even more than I imagined. I also want to thank all of the "extras" we worked with, who played a much more essential role than

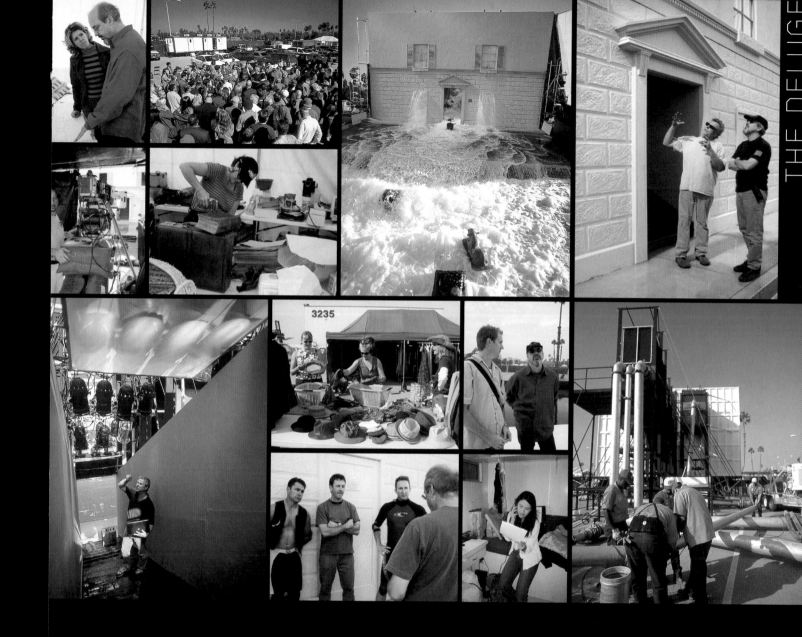

Assistant Director Kenny Bowers wrangled the unruly beast of a large on-location production with skill and solid positive energy. He was essential to the success of the shoots for "The Path," "The Deluge," and "The Voyage." Billy Campbell, Assistant Director on "First Light," brought his skills as an experienced theater director to provide essential guidance in shaping the performances in that piece as well as "The Deluge." I could not have pulled off those complex shoots without their help and skill.

Stunt Coordinator Tom Ficke and his team of stunt people brought an infectious enthusiasm, personal involvement, and impressive physical skills to the dangerous task of being swept away by a flood in "The Deluge." I especially appreciate what Tom did to stage the event and what the stunt people did to execute and improve it each time. Robbie Knott, our Water

as the cloudburst in "First Light." It was so impressive to see their expertise in harnessing a natural element I have long used in my work.

I also wish to thank Bobby Wotherspoon, Gaffer, and his team; Susan Morris, Props Manager; Laurie Ellwood, Key Wardrobe, Sarah Auernhammer, Wardrobe, and their assistants; Deborah Green, Makeup Artist; Terry Wimmer, Key Grip; and Chad Floyd, Extras Casting, for their hard work and personal involvement.

The editing stage of a project like this is a complete world in and of itself. My sincerest thanks goes to Michael Hemingway, our Post Production Supervisor, who managed the intricate complexities of scheduling, last-minute crises, the new and untried techniques of HD editing, and a bewil-

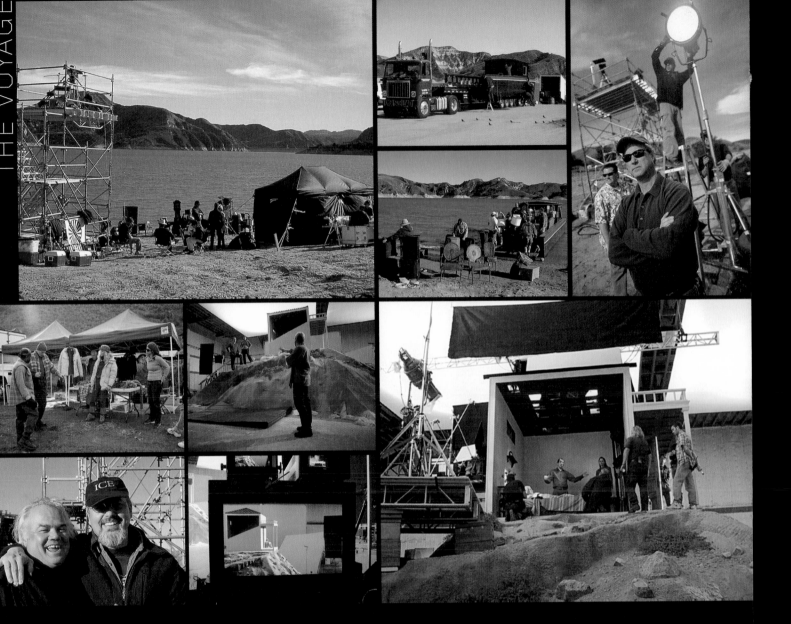

back late-night sessions, always with a cheerful smile and a hot cup of tea. His many years of experience in post production and effects work carried me through the complex process of compositing and layering of visual elements. He enlisted his colleague David Blum to supervise the special visual effects, who skillfully guided us through the perilous intricacies of wire removal and green screen matting.

Online Editor Brian Pete met the challenges of my work with a sensitive creative eye and a sure and steady hand at the computer-editing console. His calm and focused manner deftly navigated us through the most difficult and tedious moments, and his high standard of quality, attention to detail, and unblinking discerning eye (even at 3 AM) are visible in every frame. Brian greatly extended himself, working long hours and making

Mikael Sandgren, Sound Designer, did a remarkable job of gathering and composing the sounds for the series of images, which originally had none. It is a testament to his abilities and sensitive ear that many listeners will be unaware of this fact. His quiet focused manner and creative abilities are much appreciated. Mikael worked extra long hours under severe time pressure without losing the sensitivity and nuance of the soundtracks he was compiling.

Sound Mixer Mitch Dorf brought a virtuosic sense of depth and space to the final mix. He created a rich and subtle three-dimensional acoustic space within one of the simplest of sound configurations, two-speaker stereo, greatly enhancing and grounding the visual image sequences in surprisingly palpable and delicate ways. He too went the extra mile, work-

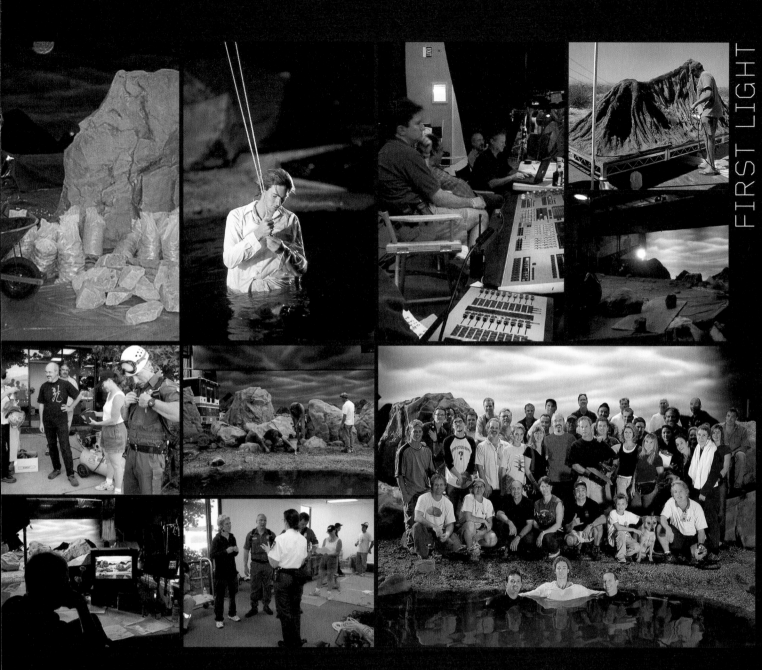

I also want to thank the companies we worked with for their support and assistance without which we never would have completed it all on time: Panavision HD division; Laser Pacific Media Corp. (thanks to Lyvonne Klingler); Soundelux (thanks to Becky Allen); POP Sound (special thanks to Steve Thompson); JBL Professional (thanks to Mark Gander, Vice President of Marketing); Visual Systems (thanks to Jim Hackett); and MediaMation, with special thanks to their programmer Takayoshi Kawakami, who provided technical support during the installation.

Finally, a special thanks to my teachers and mentors, whose work remains an inspiration and a positive force compelling and guiding me to be always moving forward and searching deeper. In preparing for this work, I was able to visit many of the major fresco cycles in the churches of Tuscany by some of the most outstanding artists of the Italian Renaissance. I owe a lot to their masterful example of how to bring their images to life within the confines of a three-dimensional architectural space and to unfold

narrative sequences in time as well, an unprecedented accomplishment at the time. In many ways their works for me are the first movies and also some of the most outstanding examples of installation art in history.

It is a privilege to be a part of the family of artists. When it comes to Art, I do not believe in the separation of past and present. Inspiration and vision are timeless and eternal, the essential nature of both artistic practice and works of art themselves. We are all contemporary beings, colleagues coexisting in the light of each other's gifts. In the second to last week of editing, Kira and I lost one of our most precious teachers, the Japanese Zen master Tanaka Sensei, when he passed on to the Nirvana world. "Five days equals five seconds!" he would say when discussing his painting. "Crying is laughing!" At other times he would suddenly declare: "All is Nothing!" with a childlike grin on is face. I dedicate this work to his memory and inspiration, a light that never will leave me.

PRODUCTION CREDITS

PRINCIPALS

BILL VIOLA DIRECTOR

KIRA PEROV EXECUTIVE PRODUCER

BETTINA JABLONSKI BILL VIOLA STUDIO DIRECTOR

S. TOBIN KIRK PRODUCER

HARRY DAWSON DIRECTOR OF PHOTOGRAPHY

WENDY SAMUELS PRODUCTION DESIGNER

TIMOTHY THOMAS ART DIRECTOR

BOBBY WOTHERSPOON GAFFER

TERRY WIMMER KEY GRIP

KENNY BOWERS ASSISTANT DIRECTOR

BILLY CAMPBELL ASSISTANT DIRECTOR

SUSAN MORRIS PROPS MANAGER

LAURIE ELLWOOD KEY WARDROBE

TOM FICKE STUNT COORDINATOR

ROBBIE KNOTT WATER EFFECTS SUPERVISOR

MICHAEL HEMINGWAY POST PRODUCTION SUPERVISOR

BRIAN PETE ONLINE EDITOR, LASER PACIFIC

MIKAEL SANDGREN SOUND DESIGNER, SOUNDELUX

MITCH DORF SOUND MIXER, POP SOUND

PERFORMERS

THE VOYAGE

JOHN FLECK SON

VALERIE SPENCER DAUGHTER-IN-LAW

LOIS STARK WOMAN ON SHORE

RICHARD STOBIE DYING MAN

ERNIE CHARLES BOATMAN

BUTCH HAMMETT BOAT LOADER 1

WILLIE JACKSON BOAT LOADER 2

BILL VIOLA GATEKEEPER

FIRST LIGHT

MELINA BIELEFELT AMBULANCE ATTENDANT

HECTOR CONTRERAS LOCAL RESCUE MEDIC

WEBA GARRETSON WOMAN ON SHORE

DAN GERRITY RESCUE MAN 1

MICHAEL ERIC STRICKLAND RESCUE MAN 2

JOHN HAY MAN RISING FROM WATER

COMBINED CREDITS

THE PATH, THE DELUGE, THE VOYAGE, FIRST LIGHT

BILL TURNER PRODUCTION COORDINATOR

GENEVIEVE ANDERSON PRODUCTION COORDINATOR

CHAD BICKELY ASSISTANT PRODUCTION COORDINATOR

BRIAN GARBELLINI CAMERA ASSISTANT

JERRY SIMER 2ND ASSISTANT DIRECTOR

JOSH LAWSON 2ND ASSISTANT DIRECTOR

RUSSELL DAPAR 2ND ASSISTANT DIRECTOR

KEN ROY HIGH DEFINITION TECHNICIAN

DEREK GROVER HIGH DEFINITION TECHNICIAN

KEVIN WILLIAMS BEST BOY ELECTRICIAN

MANNY TAPIA ELECTRICIAN

MIKE CONNORS ELECTRICIAN

PAUL MCILVAINE ELECTRICIAN

PETE RADICE LIGHT BOARD OPERATOR

JIM KWIALTKOWSKI KEY GRIP

KEN WHEELAND BEST BOY GRIP

RICK JOHNSON GRIP

PAT SKEETZ GRIP

PAT VANAUKEN GRIP

JEFF NOBEL GRIP

KEVIN ERB BEST BOY GRIP

BOB ANDERSON GRIP

BRETT BAGLEY GRIP

BILL GILLERAN GRIP

CHARLEY GILLERAN GRIP

JAMIE FRANTA GRIP

TOM BAKER GRIP

DON HASTINGS MUSCO OPERATOR

MIKE SPENCE MUSCO OPERATOR

MIKE LEBEN MOTION CONTROL PROGRAMMER

HELDER SUN MOTION CONTROL PROGRAMMER

DENNIS HOERTER MOTION CONTROL RIGGER

DEREK SCOULER ARTIST

BILLY SENDER ARTIST

DAVID WARREN ARTIST

LISA WATSON LEAD SCENIC

PAUL BICKLE SCENIC

STEVE AUERNHAMMER ARTIST

CRAIG PAVIOLLONIS ARTIST

DARRYL "SHIM" LEE LEAD CONSTRUCTION

TIM ZEUG LEAD CONSTRUCTION
IRA PROCTOR CONSTRUCTION
BILLY GRAVES CONSTRUCTION
JACK CONO CARPENTER
SHERRY PRINGLE KEY WARDROBE
SARAH AUERNHAMMER WARDROBE
BRENNA CHARLEBOIS WARDROBE ASSISTANT
JODE FELZ WARDROBE ASSISTANT
ERIKA MONRO WARDROBE ASSISTANT
HEATHER LAMKINS WARDROBE ASSISTANT
DEBORAH GREEN MAKEUP
SHARON ASAMOTO MAKEUP ASSISTANT
ROMEO SANTIAGO LOCATION MANAGER
CHAD FLOYD EXTRAS CASTING
ART CUTLER TALENT COORDINATOR
CAL SWAIN SAFETY DIVER
STEVE FICKE SAFETY DIVER
JOHN HOTT SAFETY DIVER
DAVE FORSYTHE SAFETY DIVER
JOHN STIRBER ASSISTANT WATER EFFECTS SUPERVISOR
BILL GREENE WATER EFFECTS ASSISTANT
PAUL VIGIL WATER EFFECTS ASSISTANT
BRYAN SNODGRASS LEAD WATER PRODUCTION ASSISTANT
ANNIKA ILTIS WATER PRODUCTION ASSISTANT
ADAM JORDON WATER PRODUCTION ASSISTANT
ALEX MACINNIS PRODUCTION ASSISTANT
STACY MITCHELL PRODUCTION ASSISTANT
BRANDON MCKENZIE PRODUCTION ASSISTANT
FRITZ BRUMDER PRODUCTION ASSISTANT
HEATHER GRIERSON PRODUCTION ASSISTANT
ADRIAN ECHAVEZ PRODUCTION ASSISTANT
TIM KIRK PRODUCTION ASSISTANT
JOHN STARK PRODUCTION ASSISTANT
ZACK KNIGHT PRODUCTION ASSISTANT
ANNE PAK PRODUCTION ASSISTANT
MO FREEMAN TALENT PRODUCTION ASSISTANT
TINA NIEGRO TALENT PRODUCTION ASSISTANT
JOSIAH CHOIMIERE TALENT PRODUCTION ASSISTANT
JOE WAH TALENT PRODUCTION ASSISTANT
DAVE HILCHEY BOAT CAPTAIN

MIKE HILCHEY CAPTAIN'S ASSISTANT
KIMBERLI MEYER EXHIBITION ASSISTANT, ARCHITECTURAL DRAWINGS
ARMINDA DIAZ ARCHITECTURAL DRAWINGS (THE VOYAGE)
DARIN MORAN STILLS PHOTOGRAPHER
KELLY KROTINE VIDEO DOCUMENTATION

STUNT **PERFORMERS**
THE DELUGE
ROCKY CAPELLA, JEFF SHREWSBURY, ROBAIR SIMS, MARK NEARING,
SCOTT MILLER, REX REDDICK, RANDALL HUBER, MIKE MARTINEZ,
JEFF MOSLEY, KURT JOHNSTAD, CHUCK HICKS, ROBIN BONACCORSI,
KAYE WADE, LISA DEMPSEY, JANE OSHITA, KIM COSSETTE,
LISA COHEN, MARY TORRES

CREDITS FOR FIRE BIRTH
JOEY SANTAROMANA CAMERA AND PRODUCTION ASSISTANT
ROBERT CAMPBELL CAMERA AND PRODUCTION ASSISTANT

POST PRODUCTION
LYVONNE KLINGLER CLIENT REPRESENTATIVE, LASER PACIFIC
TOM OVERTON SENIOR COLOR TIMER, LASER PACIFIC
BECKY ALLEN AUDIO PRODUCER, SOUNDELUX
DAVID BLUM VISUAL EFFECTS SUPERVISOR (THE VOYAGE), CATALYST FX

EXHIBITION HISTORY

BORN

1951 New York

EDUCATION

1973 Graduated, BFA, Experimental Studios, College of Visual and Performing Arts, Syracuse University, New York

Selected Honorary Degrees, Doctor of Fine Arts: 1995, Syracuse University, Syracuse, New York; 1997, The Art Institute of Chicago, Chicago, Illinois; 2000, California Institute of the Arts, Valencia, California; 2000, University of Sunderland, England.

SELECTED ONE-PERSON EXHIBITIONS

1973 Everson Museum of Art, Syracuse, New York, *New Video Works*, 1-21 Dec. 1973.

1974 The Kitchen, New York, Bill Viola: *Video and Sound Installations*, 19-23 Feb. 1974.

1979 The Museum of Modern Art, New York, *Projects: Bill Viola*, 14 Mar.-24 Apr. 1979.

1984 Musée d'Art Moderne de la Ville de Paris, *Bill Viola*, 20 Dec. 1983-29 Jan. 1984.

1985 Moderna Museet, Stockholm, *Bill Viola*, 27 Apr.-26 May 1985.

1987 The Museum of Modern Art, New York, *Bill Viola: Installations and Videotapes*, 16 Oct. 1987-3 Jan. 1988.

1989 Fukui Fine Arts Museum, Fukui City, Japan, Third Fukui International Video Biennale, *Bill Viola*, 29 July-20 Aug. 1989.

1990 Fondation Cartier pour l'Art Contemporain, Jouy-en-Josas, France, *Bill Viola: The Sleep of Reason*, 1 Apr.-20 May 1990.

1992 Chapelle de l'Oratoire, Musée des Beaux-Arts de Nantes, France, *Bill Viola: Nantes Triptych*, 3 July-31 Aug. 1992.

Donald Young Gallery, Seattle, Washington, *Bill Viola*, 17 Apr.-23 May 1992.

Anthony d'Offay Gallery, London, *Bill Viola: Two Installations*, 21 Oct.-20 Nov. 1992.

Kunsthalle Düsseldorf, Germany, *Bill Viola: Unseen Images/Nie gesehene Bilder/Images jamais vues*, 19 Dec. 1992-28 Feb. 1993. Traveled to: Moderna Museet, Stockholm, 4 Mar.-23 May; Museo Nacional Centro de Arte Reina Sofía, Madrid, 10 June-22 Aug.; Musée Cantonal des Beaux-Arts, Lausanne, 11 Sept.-28 Nov.; Whitechapel Art Gallery, London, 17 Dec.-13 Feb. 1994; Tel Aviv Museum of Art, 1994.

1993 Musée d'Art Contemporain de Montréal, *Bill Viola*, 21 Jan.-14 Mar. 1993.

1994 Centro Cultural Banco do Brasil, Rio de Janeiro, *Bill Viola: Território do Invisível/Site of the Unseen*, 25 June-7 Aug. 1994.

1995 Forty-Sixth Venice Biennale, Venice, United States Pavilion, *Buried Secrets* (organized by Arizona State University Art Museum, Tempe), 11 June-15 Oct. 1995. Traveled to: Kestner-Gesellschaft, Hannover, Germany, as *Bill Viola: Buried Secrets/Vergrabene Geheimnisse*, 2 Dec.-8 Jan. 1996; Arizona State University Art Museum, Tempe, 16 Mar.-16 June; Institute of Contemporary Art, Boston, 3 July-29 Sept.

1996 Durham Cathedral, Visual Arts Festival UK 1996, Durham, *Bill Viola: The Messenger* (organized by the Chaplaincy to the Arts and Recreation, Northeast England), 7 Sept.-12 Oct. 1996. Traveled to: South London Gallery, 18 Feb.-30 Mar. 1997; Anglican Cathedral, Video Positive 97, Liverpool, 11 Apr.-18 May; The Fruitmarket Gallery, Edinburgh, 7 June-26 July; Oriel Mostyn Center for Visual Arts, Gwynedd, Wales, 2 Aug.-6 Sept.; Ormeau Baths Gallery, Belfast, 6-29 Nov.; Douglas Hyde Gallery, Trinity College, Dublin, 10 Dec. 1997-31 Jan. 1998; Museum Bochum, Bochum, Germany, 17 May-5 July; Old Melbourne Gaol, The Melbourne Festival, 17 Oct.-1 Nov.

Chapelle Saint-Louis de la Salpêtrière, Paris, Festival d'Automne, *Bill Viola: Trilogy: Fire, Water, Breath*, 11 Oct.-10 Nov. 1996.

1997 Guggenheim Museum SoHo, New York, *Bill Viola: Fire, Water, Breath*, 18 Jan.-23 Mar. 1997.

Whitney Museum of American Art, New York, *Bill Viola: A Twenty-Five-Year Survey*, 12 Feb.-10 May 1998. Traveled to: Los Angeles County Museum of Art, 2 Nov. 1997-11 Jan. 1998; Stedelijk Museum, Amsterdam, 12 Sept.-29 Nov. 1998; Museum für Moderne Kunst, Frankfurt, 5 Feb.-25 Apr. 1999; San Francisco, San Francisco Museum of Modern Art, 25 June-12 Sept. 1999; Art Institute of Chicago, 16 Oct. 1999-9 Jan. 2000.

2000 Helaba Main Tower, Frankfurt, *The World of Appearances*, 2000. Permanent installation.

Museum für Neue Kunst, Karlsruhe, Germany, *Bill Viola: Stations*, 16 Apr.-1 Oct. 2000.

James Cohan Gallery, New York, *Bill Viola: New Work*, 15 Oct.-26 Nov. 2000.

2001 Anthony d'Offay Gallery, London, *Bill Viola: Five Angels for the Millennium and other New Works*, 2 May-21 July 2001.

SELECTED GROUP EXHIBITIONS

1974 Kunstverein, Cologne, and Kunsthalle Cologne, *Kunst bleibt Kunst: Projekt '74*, 6 July-8 Sept. 1974.

1975 Whitney Museum of American Art, New York, 1975 *Biennial Exhibition*, 20 Jan.-9 Apr. 1975.

1977 Friedericianum, Kassel, Germany, *Documenta 6*, 24 June–2 Oct. 1977.

1983 The Art Gallery at Harbourfront, Toronto, Video Culture, Canada International Video Festival, *Noel Harding and Bill Viola: Two Video Installations*, 21 Oct.–6 Nov. 1983.

1984 Stedelijk Museum, Amsterdam, *Het lumineuze beeld/The Luminous Image*, 14 Sept.–28 Oct. 1984.

1987 Los Angeles County Museum of Art, Los Angeles, *Avant-Garde in the Eighties*, 23 Apr.–12 July 1987.

1988 The Carnegie Museum of Art, Pittsburgh, *American Landscape Video: The Electronic Grove*, 7 May–10 July 1988. Traveled to: San Francisco Museum of Modern Art, 10 Nov. 1988–19 Feb. 1989.

1990 Whitney Museum of American Art, New York, *Image World: Art and Media Culture*, 8 Nov. 1989–18 Feb. 1990.

Musée National d'Art Moderne, Centre Georges Pompidou, Paris, *Passages de l'image*, 18 Sept. 1990–13 Jan. 1991. Traveled to: Centre cultural de la Fundació Caixa de Pensions, Barcelona, 12 Feb.–28 Mar. 1991; Wexner Center for the Arts, Columbus, Ohio, 1 June–27 Oct. 1991; San Francisco Museum of Modern Art, 2 Feb.–12 Apr. 1992.

1991 Museum für Moderne Kunst, Frankfurt, *Eröffnungsausstellung/ Opening Exhibition*, 6 June 1991.

1992 Kassel, Germany, *Documenta 9*, 13 June–20 Sept. 1992.

1993 Martin-Gropius-Bau, Berlin, and The Royal Academy of Arts, London, *American Art in the Twentieth Century: Painting and Sculpture, 1913–1993*, 8 May–25 July (Berlin), 16 Sept.–12 Dec. (London), 1993.

1994 American Center, Paris, *Bill Viola: Stations,* part of inaugural exhibition, 7 June–1 Dec. 1994.

Denver Art Museum and Columbus Museum of Art, Columbus, Ohio, *Visions of America: Landscape as Metaphor in the Late Twentieth Century*, 14 May–11 Sept. 1994 (Denver); 16 Oct.–8 Jan. 1995 (Columbus).

1995 The Museum of Modern Art, New York, *Video Spaces: Eight Installations*, 21 June–12 Sept. 1995.

Tate Gallery, London, *Rites of Passage: Art for the End of the Century*, 15 June–3 Sept. 1995.

Musée d'Art Contemporain, Lyon, France, *3e Biennale d'art contemporain de Lyon*, 20 Dec. 1995–18 Feb. 1996.

1996 International Center of Photography, New York, organizers, *Along the Frontier: Ann Hamilton, Bruce Nauman, Francesc Torres, Bill Viola*. Exhibited at: The State Russian Museum, St. Petersburg, 14 June–20 Aug. 1996; Galerie Rudolfinum, Prague, 18 Sept.–24 Nov.; National Gallery of Contemporary Art, Warsaw, 16 Dec. 1996–20 Jan. 1997; Soros Center for Contemporary Art, Ukranian House Gallery, Kiev, 8 Mar.–3 May 1997.

Albright-Knox Art Gallery, Buffalo, New York, *Being and Time: The Emergence of Video Projection*, 21 Sept.–1 Dec. 1996. Traveled to: Cranbrook Art Museum, Bloomfield Hills, Michigan, 24 Jan.–29 Mar. 1997; Portland Art Museum, Portland, Oregon, 24 May–27 July; Contemporary Arts Museum, Houston, 16 Aug.–12 Oct.; Site Santa Fe, New Mexico, 1 Nov. 1997–31 Jan. 1998.

1997 Fabric Workshop and Museum, Philadelphia, organizers, *Changing Spaces*. Exhibited at: Miami Art Museum, Miami, 13 June–17 Aug. 1997; Atlanta College of Art Galleries, Arts Festival of Atlanta, 5 Sept.–30 Oct.; Detroit Institute of Arts, 16 Jan.–22 Feb. 1998; Vancouver Art Gallery, 29 Apr.–7 Sept.

1999 Whitney Museum of American Art, New York, *The American Century: Art & Culture 1900–2000, Part II, 1950–2000*, 26 Sept. 1999–13 Feb. 2000.

2000 National Gallery, London, *Encounters: New Art from Old*, 14 June–17 Sept. 2000.

Hayward Gallery, London, *Spectacular Bodies: The Art and Science of the Human Body from Leonardo to Now*, 19 Oct. 2000–19 Jan 2001.

2001 Forty-Ninth Venice Biennale, *Plateau of Humankind*, 10 June–4 Nov. 2001.

Museum Boijmans Van Beuningen, Rotterdam, Netherlands, *Hieronymous Bosch*, 1 Sept.–11 Nov. 2001.

Musée d'Art Contemporain de Montréal, Montreal, *Artcité: When Montreal Turns into a Museum*, 10 Aug.–8 Oct. 2001.

SELECTED PRESENTATIONS OF *DÉSERTS*, A FILM CREATED FOR THE MUSIC COMPOSITION *DÉSERTS* BY EDGARD VARÈSE

1994 Wien Modern, Konzerthaus, Vienna, a collaboration with the Ensemble Modern, conducted by Peter Eötvös, premiere: 23 October 1994. Other performances: Muffathalle, Munich, 19 May 1995; Palazzetto dello Sport, Venice, 9 June; Hallein/Perner-Insel, Salzburg, 2 Aug.; Alte Oper, Frankfurt, 17 Sept.; Konzerthaus, Berlin, 21 Sept.; Concertgebouw, Amsterdam, 21 Oct.; Royal Festival Hall, London, 18 Feb. 1996; Globe Arena, Stockholm, 26 Feb.; Théâtre des Champs-Élysées, Paris, 12 Oct.

1999 Hollywood Bowl, Los Angeles, *Fantastic Odyssey* programme, *Déserts* performed by the Los Angeles Philharmonic, conducted by Esa-Pekka Salonen, 24 Aug. 1999.

2000 Barbican Centre, London, *Fire Crossing Water* festival, *Déserts* performed by the BBC Symphony Orchestra, conducted by Pierre André Valade, 1 Oct. 2000.

2001 Carnegie Hall, New York, *Technology and the Orchestra* programme, *Déserts* performed by American Composers Orchestra, conducted by Paul Lustig Dunkem, 14 Oct. 2001.

BIBLIOGRAPHY

SELECTED ARTIST'S WRITINGS

Bill Viola: Statements by the Artist (exh. cat.). Introduction by Julia Brown. Los Angeles: Museum of Contemporary Art, 1985.

Reasons for Knocking at an Empty House: Writings 1973–1994. Edited by Robert Violette with Bill Viola. Cambridge, Mass.: MIT Press; London: Thames and Hudson; Anthony d'Offay Gallery, 1995.

SELECTED BOOKS AND CATALOGUES

Bélisle, Josée, ed. *Bill Viola* (exh. cat.). Texts by Josée Bélisle and Bill Viola. Montreal: Musée d'art contemporain de Montréal, 1993. In English and French.

Bill Viola (exh. cat.). Texts by Anne-Marie Duguet, John G. Hanhardt, Kathy Huffman, Suzanne Page, and Bill Viola; interview with the artist by Deirdre Boyle. Paris: ARC, Musée d'Art Moderne de la Ville de Paris, 1983. In English and French.

Bill Viola (exh. cat.). Contributions by Lewis Hyde, Kira Perov, David A. Ross, and Bill Viola. New York: Whitney Museum of American Art; Paris: Flammarion, 1997. German edition. Stuttgart: Cantz, 1999.

Bill Viola: Território do Invisível/Site of the Unseen (exh. cat.). Texts by Ivana Bentes, Marcello Dantas, and Kathy Huffman; interview with the artist by Jörg Zutter. Rio de Janeiro: Centro Cultural Banco do Brasil, 1994. In English and Portuguese.

Feldman, Melissa and H. Ashley Kistler, eds. *Bill Viola: Slowly Turning Narrative* (exh. cat.). Philadelphia: Institute of Contemporary Art; Richmond: Virginia Museum of Fine Arts, 1992.

Hanhardt, John. G. "Cartografando il visibile: l'arte di Bill Viola." In Valentina Valentini, ed., *Ritratti: Greenaway, Martinis, Pirri, Viola*. Taormina, Italy: De Luca, 1987. In Italian.

——. *Bill Viola: Fire, Water, Breath* (exh. brochure.). New York: Guggenheim Museum, 1997.

Heiferman, Marvin, and Lisa Phillips, with John G. Hanhardt. *Image World: Art and Media Culture* (exh. cat.). New York: Whitney Museum of American Art, 1989.

Livingstone, Marco. "Bill Viola." In Richard Morphet, *Encounters: New Art from Old* (exh. cat.). London: National Gallery, 2000.

Loisy, Jean de, ed. *Bill Viola: The Sleep of Reason* (exh. cat.). Jouy-en-Josas, France: Fondation Cartier pour l'Art Contemporain, 1990. In French.

London, Barbara, ed. *Bill Viola: Installations and Videotapes* (exh. cat.). Texts by J. Hoberman, Donald Kuspit, Barbara London, and Bill Viola. New York: Museum of Modern Art, 1987.

Nusser, Uta, ed. *Bill Viola: Stations* (exh. cat.). Texts by Martin Hentschel, Hannelore Paflik-Huber, and Bill Viola. Stuttgart: Württembergischer Kunstverein; Los Angeles: Lannan Foundation, 1996. In English and German.

Pühringer, Alexander, ed. *Bill Viola* (exh. cat.). Texts by Freidemann Malsch, Celia Montolió, Otto Neumaier, and Bill Viola; interview with the artist by Otto Neumaier and Alexander Pühringer. Salzburg: Salzburger Kunstverein, 1994. In English and German.

Sparrow, Felicity, ed. *Bill Viola: The Messenger* (exh. cat.). Texts by David Jasper and Stuart Morgan. Durham: Chaplaincy to the Arts and Recreation in Northeast England, 1996.

Stations: Bill Viola (exh. cat.). Introduction by Götz Adriani; texts by Reto Krüger, Ralph Melcher, Bill Viola, and Dörte Zbikowski. Karlsruhe, Germany: Museum für Neue Kunst/ZKM, 2000. In German.

Syring, Marie Luise, ed. *Bill Viola: Unseen Images/Nie gesehene Bilder/Images jamais vues* (exh. cat.). Texts by Rolf Lauter and Marie Luise Syring; interview with the artist by Jörg Zutter. Düsseldorf: Kunsthalle Düsseldorf, 1992. In English, French, and German. Reprinted and expanded as *Bill Viola: Más allá de la mirada (imágenes no vistas)*. Madrid: Museo Nacional Centro de Arte Reina Sofía, 1993. In Spanish.

Valentini, Valentina, ed. *Taormina Arte 1993: Bill Viola: Vedere con la mente e con il cuore*. Text by Valentina Valentini and Bill Viola; interview with the artist by Jörg Zutter, and interview with David A. Ross by Gianfranco Mantegna. Rome: Gangemi Editore, 1993. In English and Italian.

Yapelli, Tina with Toby Kamps. *Bill Viola: Images and Spaces* (exh. cat.). Texts by Tina Yapelli and Bill Viola. Madison, Wisc.: Madison Art Center, 1994.

Zeitlin, Marilyn A., ed. *Bill Viola: Survey of a Decade* (exh. cat.). Texts by Deirdre Boyle, Kathy Rae Huffman, Christopher Knight, Michael Nash, Joan Seeman Robinson, Gene Youngblood, and Marilyn A. Zeitlin. Houston: Contemporary Arts Museum, 1988.

——. *Bill Viola: Buried Secrets/Segreti sepolti* (exh. cat.). Texts by Bill Viola and Marilyn A. Zeitlin. Tempe: Arizona State University Art Museum, 1995. In English and Italian. Reprinted and expanded as *Bill Viola: Buried Secrets/Vergrabene Geheimnisse*. Texts by Carl Haenlein, Susie Kalil, Bill Viola, and Marilyn Zeitlin. Hannover, Germany: Kestner-Gesellschaft, 1995. In German and English.

SELECTED ARTICLES AND REVIEWS

Albertini, Rosanna. "Bill Viola: l'oeil de la séparation (The Dividing Eye)." *Art Press* (Paris) no. 233 (March 1998), pp. 20–25. In English and French.

Artner, Alan G. "Time Traveler." *Chicago Tribune*, 31 October 1999, pp. 1, 12.

Bellour, Raymond. "An Interview with Bill Viola." *October* (Cambridge, Mass.) no. 34 (fall 1985), pp. 91–119. Also published as "Entretien avec Bill Viola: L'espace à pleine dent," *Cahiers du cinéma* (Paris) no. 379 (January 1986), pp. 35–42; and "Où va la Vidéo," *Cahiers du cinéma* special issue, ed. Jean-Paul Fargier, no. 14 (1986), pp. 64–73. In English and French.

Bloch, Dany. "Les Vidéo-paysages de Bill Viola." *Art Press* (Paris) no. 80 (April 1984), pp. 24–26. In English and French.

Boyle, Deirdre. "Post-Traumatic Shock: Bill Viola's Recent Work." *Afterimage* (Rochester, NY) no. 24 (September–October 1996), pp. 9–11.

Cecco, Emanuela de. "Bill Viola: Tra fisica e metafisica." *Flash Art* (Milan) 26, no. 179 (November 1993), pp. 31–34.

Cumming, Laura. "A Rembrandt for the Video Age." *The Observer* (London), 6 May 2001, p. 11.

Daniels, Dieter. "Bill Viola: Installations and Videotapes." *Kunstforum* (Mainz) no. 92 (December 1987–January 1988), pp. 247–50. In German.

Danto, Arthur. "TV and Video." *The Nation* (New York), 11 September 1995, pp. 248–53.

Denny, Ned. "Viola Bodies." *New Statesman* (London), 28 May 2001, pp. 45–46.

Drohojowska-Philp, Hunter. "His Camera Never Blinks." *Los Angeles Times*, 26 October 1997, Calendar section, pp. 3, 69.

_____. "The Self-Discovery Channel." *Art News* (New York) 96, no.10 (November 1997), pp. 206–09.

_____. "First the Soundtrack, Now the Film." *Los Angeles Times*, 22 August 1999, Calendar section, pp. 52, 73–74.

Duguet, Anne-Marie. "Les vidéos de Bill Viola: une poétique de l'espace-temps." *Parachute* (Montreal) no. 45 (December 1986–February 1987), pp. 10–15 in French; pp. 50–53 in English. Abridged version published in *Expansion and Transformation: The Third Fukui International Video Biennale* (exh. cat.). Fukui, Japan: Fukui International Video Biennale Executive Committee, 1989.

Duncan, Michael. "Bill Viola: Altered Perceptions." *Art in America* (New York) 86, no. 3 (March 1998), pp. 62–69.

Grant, Simon. "This Work Would Make the Angels Weep." *The Independent on Sunday* (London), 6 May 2001, pp. 1, 4.

Hierholzer, Michael. "Berührung der Gegensätze im dunklen Raum." *Frankfurter Allgemeine Magazin*, 7 February 1999, p. 25.

Hohmeyer, Jürgen. "Flimmern im Brunnen." *Der Spiegel* (Berlin), no. 53 (December 1992), pp. 170–71.

Januszczak, Waldemar. "Magical, Mystical, Magnificent." *The Sunday Times* (London), 26 April 1998, section 11, pp. 8–9.

Kuspit, Donald. "The Passing." *Artforum* (New York) 32, no. 1 (September 1993), pp. 145, 204.

Mejias, Jordan. "Bill Viola: Die kunst, der tod und das teetrinken." *Frankfurter Allgemeine Magazin*, 5 February 1999, cover, pp. 10–19.

Nash, Michael. "Bill Viola." *Journal of Contemporary Art* (New York) 3, no. 2 (fall/winter 1990), pp. 63–73.

Neumaier, Otto and Alexander Pühringer. "Buried Secrets: Bill Viola im Gespräch mit Otto Neumaier und Alexander Pühringer." *Noëma* (Salzburg) no. 40 (winter 1995–96), pp. 20–35.

Plagens, Peter. "The Video Vibes of Venice." *Newsweek* (New York), 17 July 1995, p. 59.

Rutledge, Virginia. "Art at the End of the Optical Age." *Art in America* (New York) 86, no. 3 (March 1998), pp. 70–77.

Solomon, Andrew. "Bill Viola's Video Arcade." *New York Times Magazine*, 8 February 1998, pp. 34–37.

Youngblood, Gene. "Metaphysical Structuralism: The Videotapes of Bill Viola." *Millennium Film Journal* (New York) no. 20/21 (fall/winter 1988–89), pp. 80–114. First published under same title for the laser-disc edition of *Bill Viola: Selected Works*. Los Angeles: Voyager, 1987.

FRESCOES OF LIGHT

In *Going Forth By Day*, Bill Viola has created a unique work linking fresco painting to state-of-the-art video technology for the Deutsche Guggenheim Berlin. An opus in five chapters, the piece interprets biblical and mythological themes in the spirit of our times. Through the first projection, "Fire Birth," the observer enters the installation and, by doing so, becomes an element of the work of art. Comparable to frescoes, the images appear directly on the walls and encompass the entire space, and, like frescoes in their ideal form, they connect time and space. Each projection displays an independent event in time while together the chapters simultaneously represent a general chronological development.

"A hall of moving images . . . parallel worlds . . . a walk-in movie." These were Bill Viola's words in 1999 when he presented the first concept for the commission in Berlin. His work was inspired by a visit to the Scrovegni Chapel in Padua, where Giotto's frescoes adorn the walls. According to Viola, the chapel is "one of the great works of installation art." Allegories from *Going Forth By Day* transposed into the present exemplify a way of life that is determined by human interaction and confrontation with nature's elements.

Recorded in the new digital medium of High-Definition video, Viola's work places the observer under his spell. Despite its brilliance, the technology remains invisible and is only a means to an end. It is clear that the artist wishes to capture our senses and thoughts through the power of fascination, forcing a deeper contemplation of our world.

Dr. Rolf-E. Breuer
Spokesman of the Board of Managing Directors
of Deutsche Bank AG

Deutsche Guggenheim BERLIN

Deutsche Guggenheim Berlin is a unique joint venture between a corporation—Deutsche Bank—and a nonprofit arts foundation—The Solomon R. Guggenheim Foundation. Designed by American architect Richard Gluckman, the 510-square-meter gallery is located on the ground floor of the Deutsche Bank headquarters in Berlin. Since opening in fall 1997, Deutsche Guggenheim Berlin has presented three to four important exhibitions each year, many of which showcase a specially commissioned work by an artist. The exhibition program and day-to-day management of the museum is the responsibility of the two partners.

Deutsche Guggenheim Berlin joins the Solomon R. Guggenheim Foundation's other locations: the Solomon R. Guggenheim Museum in New York; the Peggy Guggenheim Collection in Venice; the Guggenheim Museum Bilbao; and the Guggenheim Las Vegas and Guggenheim Hermitage Museum, both in Las Vegas. Deutsche Bank regularly supports exhibitions in renowned museums, and, since 1979, has been building up its own collection of contemporary art under the motto "art at the workplace." The Deutsche Guggenheim Berlin initiative further represents a milestone in Deutsche Bank's advancement of the arts.

EXHIBITIONS AT DEUTSCHE GUGGENHEIM BERLIN SINCE ITS FOUNDING IN 1997:

1997 Visions of Paris: Robert Delaunay's Series

1998 James Rosenquist: The Swimmer in the Econo-mist*

From Dürer to Rauschenberg: A Quintessence of Drawing. Masterworks from the Albertina and the Guggenheim

Katharina Sieverding: Works on Pigment

After *Mountains and Sea*: Frankenthaler 1956–1959

1999 Andreas Slominski*

Georg Baselitz—Nostalgia in Istanbul

Amazons of the Avant-Garde: Alexandra Exter, Natalia Goncharova, Liubov Popova, Olga Rozanova, Varvara Stepanova, and Nadezhda Udaltsova

Dan Flavin: The Architecture of Light

2000 Sugimoto: Portraits*

Förg—Deutsche Bank Collection

Lawrence Weiner: Nach Alles/After All*

Jeff Koons: Easyfun-Ethereal*

2001 The Sultan's Signature: Ottoman Calligraphy from the Sakip Sabanci Museum, Sabanci University, Istanbul

Neo Rauch—Deutsche Bank Collection

On the Sublime: Mark Rothko, Yves Klein, and James Turrell

Rachel Whiteread: Transient Spaces*

*Commissioned work by Deutsche Guggenheim Berlin

ACKNOWLEDGMENTS

Bill Viola's *Going Forth By Day* is an extraordinary achievement. With this newly commissioned project, Bill Viola has created a twenty-first-century fresco, an aesthetic text that, like the work of the great artists of the Renaissance, transforms how we see and imagine the world. Bill's new work for the Deutsche Guggenheim Berlin underscores the densely layered, synthesizing vision that the artist brings to his complex installations, achieving a sophisticated realization in *Going Forth By Day* through the resources of state-of-the-art digital technology. Here is one of the great artists of our time seeking to create a new moving image that will speak to past artistic achievements while articulating this goal through a distinctly unique and contemporary visual language. In the process, *Going Forth By Day* reflects Viola's renewing humanistic vision that speaks to hope and to the constructive power of the imagination.

There are a number of individuals to whom I wish to express my gratitude in realizing a project that at every step became more ambitious and complicated and required the support and understanding of many people. Deutsche Bank and the Deutsche Guggenheim Berlin have been unwavering in their commitment and support of this complex endeavor. I would like to especially acknowledge Dr. Rolf-E. Breuer, Spokesman of the Board of Managing Directors of Deutsche Bank, for his insight into the importance of art for our time. At the Deutsche Guggenheim Berlin, I'd like to thank Dr. Ariane Grigoteit and Friedhelm Hütte, Deutsche Bank Collection Curators; as well as Svenja Simon, Deutsche Guggenheim Berlin Gallery Manager, and Sara Bernshausen, for their continued contribution to the ambitious commissioning program of the Deutsche Guggenheim Berlin.

At the Solomon R. Guggenheim Museum in New York I want to thank John G. Hanhardt, Senior Curator of Film and Media Arts, and curator of this exhibition, who is leading the Guggenheim Museum's global film and media arts program and who has worked on numerous exhibitions and projects over the years with Bill Viola. Maria-Christina Villaseñor, Associate Curator of Film and Media Arts, brilliantly managed every phase of this large and complex undertaking. Thanks are also due to Kevin Murphy, former Administrative Assistant, Film and Media Arts, for his tireless efforts in preparing materials for the exhibition; and to Paul Kuranko, Media Arts Specialist, who brought his great technical knowledge to all aspects of this project and worked closely with the artist's studio. I also want to offer special thanks to Lisa Dennison, Deputy Director and Chief Curator, who enthusiastically lent her expertise to this project from its inception. Essential in negotiating the complexities of the commission were Jane DeBevoise, Deputy Director for Program Administration; Marion Kahan, Exhibition Program Manager; Maria Pallante, Associate General Counsel; Anna Lee, Director of Global Programs; and Christina Kallergis, Financial Analyst, whose skilled and committed contributions to realizing this work are greatly appreciated.

Bill Viola's studio is a most professional operation directed by Kira Perov, Bill's wife. Kira contributed immeasurably to this entire undertaking, tirelessly overseeing all facets of the project and serving as Editorial Director for the two publications. Thanks are due to the remarkable group at the studio and office. Bettina Jablonski, Studio Director, assisted by Kimberli Meyer, meticulously managed every aspect of the physical installation of the work, from researching and finalizing the equipment and creating technical drawings, to supervising the installation on site. S. Tobin Kirk, in-house Producer, skillfully handled all the complex details of these enormous productions, ably assisted by Coordinators Genevieve Anderson and Bill Turner. A core team of film professionals provided invaluable assistance to Bill Viola in producing each panel: Director of Photography Harry Dawson, Production Designer Wendy Samuels, Props Manager Susan Morris, Assistant Director Kenny Bowers, Post Production Supervisor Michael Hemingway, and Online Editor Brian Pete. Thanks are also due to studio Bookkeeper Marie Slaton, who met the challenges of this large project with enthusiasm, and Traci Furan and Ann Do for their organization of the catalogue as well as other myriad details related to the exhibition.

Rebeca Méndez, the catalogue designer, and Snow Kahn, also worked closely with Bill and Kira and realized a splendid interpretation in print of *Going Forth By Day*. James Cohan, of the James Cohan Gallery, lent his support to all phases of this commission, as did Anthony d'Offay.

It has been a profound pleasure to know and work with Bill Viola. He is an artist of enormous integrity and vision, who is charting a new and brilliant path for the visual arts.

Thomas Krens
Director, The Solomon R. Guggenheim Foundation

Published on the occasion of the exhibition
Bill Viola: Going Forth By Day
Organized by John G. Hanhardt with Maria-Christina Villaseñor

Deutsche Guggenheim Berlin
9 February–5 May 2002

Deutsche Bank & Solomon R. Guggenheim Foundation

Bill Viola: Going Forth By Day

ISBN: 0-89207-255-5

Guggenheim Museum Publications
1071 Fifth Avenue
New York, New York 10128

Deutsche Guggenheim Berlin
Unter den Linden 13–15
10117 Berlin

Editorial Director: Kira Perov
Design: Rebeca Méndez and Snow Kahn,
Rebeca Méndez Communication Design/Ogilvy&Mather
Editorial and Production: Guggenheim Museum Publications Department
Printed in Germany by Cantz

LIST OF ILLUSTRATIONS

ALL DESCRIPTIVE TEXTS, NOTEBOOK ENTRIES, DRAWINGS AND EXHIBITION PLANS ARE BY BILL VIOLA

The bird of vision is flying towards you
on the wings of desire.

Rumi

① Fire | Birth

17'04"

13'0"

4:3 ASPECT

② The Path

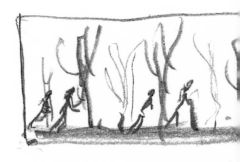

③ The Deluge

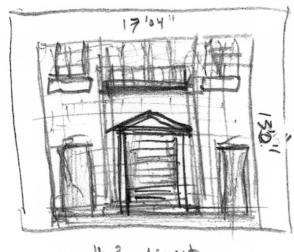

17'04"

13'0"

4:3 Aspect

④ The Crossing

13'04"

7'06"

16:9 Aspect

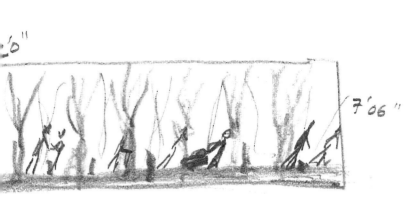

2'0"

7'06"

③

④

②

⑤

①

↑ Entry Exit

Floor Plan

⑤ Resurrection

10'0"

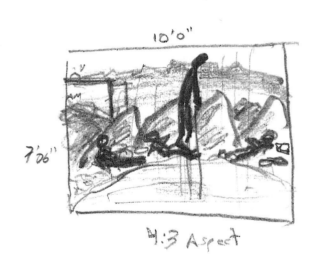

7'06"

4:3 Aspect

Berlin Guggenheim

FRESCO CYCLE for Deutsche Guggenheim

For Johann, (Space and Time)

long Beach 11 July 2001

1. FIRE / BIRTH

Naked Man in murky
underwater environment.

Light is pure FIRE –
 orange, yellow, red shafts of
 light flicker and shimmer
 on his body – Never fully visible.

Proc

1. Secure FOOTAGE — Existing 3/4" ok?

2. OFF LINE EDIT (BVS)

3. COLORIZE (BVS)

4. EDIT

(A)
Final Cut/G4
After Effects
(SloMo)
Computer File

(B) RIOT
Randy — RTD SloMo

D. Beta MASTER

5. UP RES to _____? — HD? ✓
— SXGA?
— VGA?

Yes — HD res for
Final — 1920 x 1080i

(Xfer to) — NTSC (DVD)?

— SCALER REQUIRED? —
OR PROJECTOR CAN DO?

(Projector does SCALING)

X NO — Up res
before Final Master

...th analog equipment.

...lley model 100 switcher

...atte Key and color bkg. gen.

...alog slow motion

The previous world ended in Fire.

2. The PATH

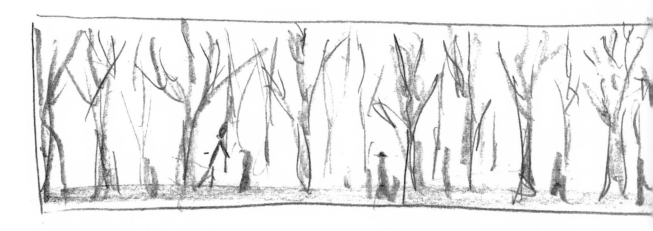

LOCATION

Orientation - E N W S

- How long PATH?
 - Size of people in frame?

DURATION - Action
 - Screen
Slo Mo Needed?

OUTDOORS - 2 takes per day
 · Weather
 · Nature ('real')

INDOORS - Sets, Props
 - Controlled Lighting
 - Background/Depth?

SCENE - ~~Burned Out~~ ?
 Verdant

TIME/LIGHT - AM, PM?

TREES

TALENT - Number of People? Dispersal?
 - SAG, Non-SAG?
 - Extras, Actors.
 - Wardrobe

 - Rehearsals Staging Action

 - Time Score of Action

OVERLAP
ZONES

① ② ③

3 Cameras. Simultaneous
record

NODAL VIEW.
All cameras equi-distant
to path.

① LEFT		② CENTER		③ RIGHT

FINAL PANORAMA PROJECTION - with digital edge blending

TESTS/QUESTIONS

- Length of Path
- ARE OK? or angeled
= Focal Length
- Number of People
- Clothes, Details

Edge Blending:
- How to align the 3 cameras in the field?
- Physical grid system required in overlap zones?

PANORAMA

- 1 Camera / Multi camera ?
Source
- Format 35mm / HD ?

...ch:
Final - HD Resolution ?
Res. · SXGA - 4 panels ?
 · VGA - 4 panels ? (recommended by PANORAM)
Editing - 4:3 component frames,
 DVD or MPEG Player NTSC ?
 - 16:9 component frames ?

...oramic System:

Panoram Systems ?

Other ? (incl. IN PROJECTOR)

- CUSTOM DESIGN Cam. mount
 for 3 Cameras.

③ The DELUGE

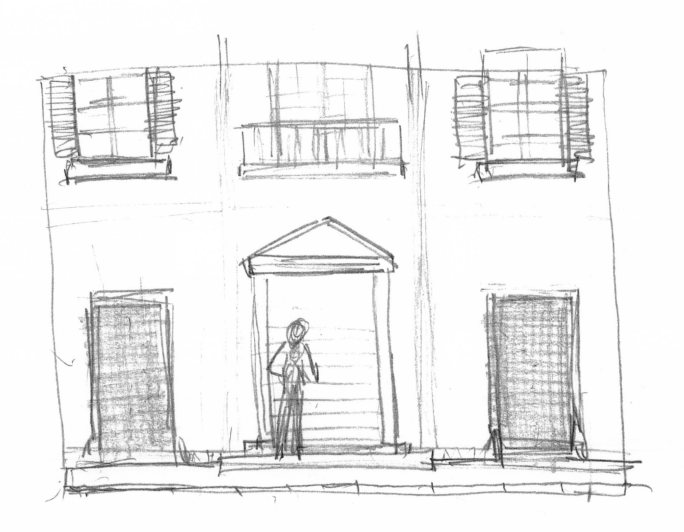

SET ·

- Size Doorway
 - scale of people

- Facade - Size
 - Scale
 - Texture/Materials
 - Color
- Design/Proportions (Bill, Wendy)
- Construction/Engineering

Talent
- Stunts
- Extras
- Actors

- How many people ?
- Wardrobe

Props

- Carrying objects
- Objects in Water

ACTION

- Overall time sequence

- Actors - T

- Duration of Flood
 - People in water
 - Props in Water

The glaring light of day –
Stark reality

LIGHTING – ? How much?

Duration – whole

Timeline action

Time between takes

How big person? (vis a vis SET)

LOCATION

- Indoor ? – Block external light

- Outdoor ? – Lighting Constant?
 – If Night – ambient light?

SOUND – Live?
 Mixed?

SET DESIGN –
Cross section

window

BLDG
FACADE

Sidewalk Door

containment
reservoir

PUMPS

Water Pipe

WATER

- Duration flood

- Sequencing of flood –
 (Door, Windows)

- Volume of Water

- Time between Takes?
 ReFills
 Excess Water?
 Drying time? (Set materials)

TESTS

- Small Model / Garden Hose
 (Slow down, Duration of flood)

- HD Slo Mo – parameters
 – quality

- Framing, Height doorway.
 Width of sidewalk

4. The Crossing (Salton Sea)

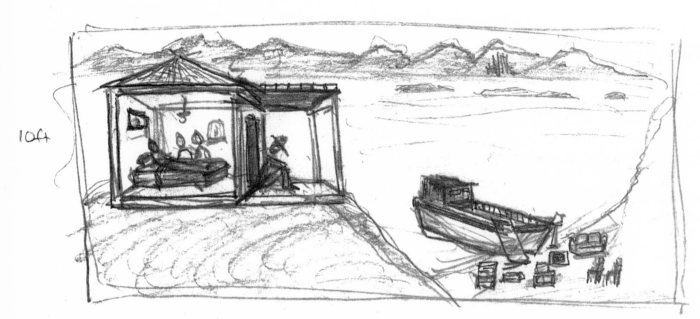

10 ft

Voyage to the distant shore.

SETS

HOUSE
- Geometric Distortion?. How much?
 - What?.
 - Constructed exterior w/ forced or altered perspective?

- EXTERIOR - (Transportable) Flexible Wall angles

INTERIOR - Constructed in studio. Bed, chairs, picture, alcove, lamp

PROPS

HOUSE - Bed, Covers
Wall Art
Light
Niche
chair?
Table?

BOAT - Furnish
TV
Chairs
Couch
Bed
Tables
Lamps

TALENT

HOUSE
Interior: 3 people - Old Man
Younger Couple

Exterior: Seated Man
Young couple

BEACH: 6 movers
- Old Woman
- Old Man
- Boat Driver

Time/Light: Late Afternoon

DIGITAL COMPOSITING - 'Giornate'

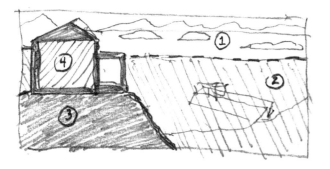

TESTS

· House - interior mate to exterior
Geometry?

1- The Isles of the Blessed - BACKGROUND PLATE
2. The Near Shore and Boat - MID GROUND PLATE
3. EARTH HOUSE - House on the Hill - FOREGROUND PLATE
4. The PORTAL - the death room - INTERIOR PLATE

LOCATION

· Salton Sea
· Lake Matthews
· Lake Airu

Timeline

Timelapse Sunset

ACTION

Couple attending father's death bed.
Man keeping vigil outside door.
Boat being loaded for voyage to the far shore.

EFFECTS

Poss. Composite Elements:

· House interior
· House exterior
· Beach w/ Boat
- Mountains
· Distant City

Digital Stills

hi res 2m pixel
mts, city, etc.

5. — The Resurrection

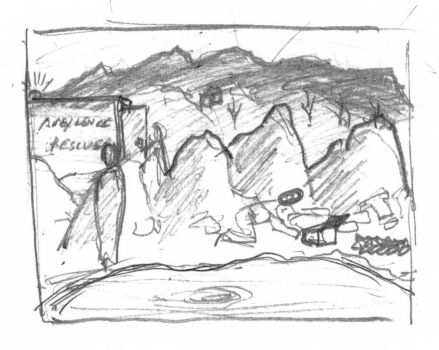

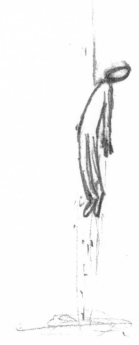

Talent.

4 Rescue Guys

1 Woman

1 Angel – MANNEKIN?

Wardrobe

- Firemen, Coast Guard,
 Paramedics

- Woman – Shawl, Blanket

- ANGEL – Clothes.

Set

Size: Boulders, Pebbles, Rocks

Shoreline – Shape

Backdrop – Trans-Light
 – Projection Screen?

Mid-Ground –

Rain · Depth?

- Drips off man

- Sequencing?

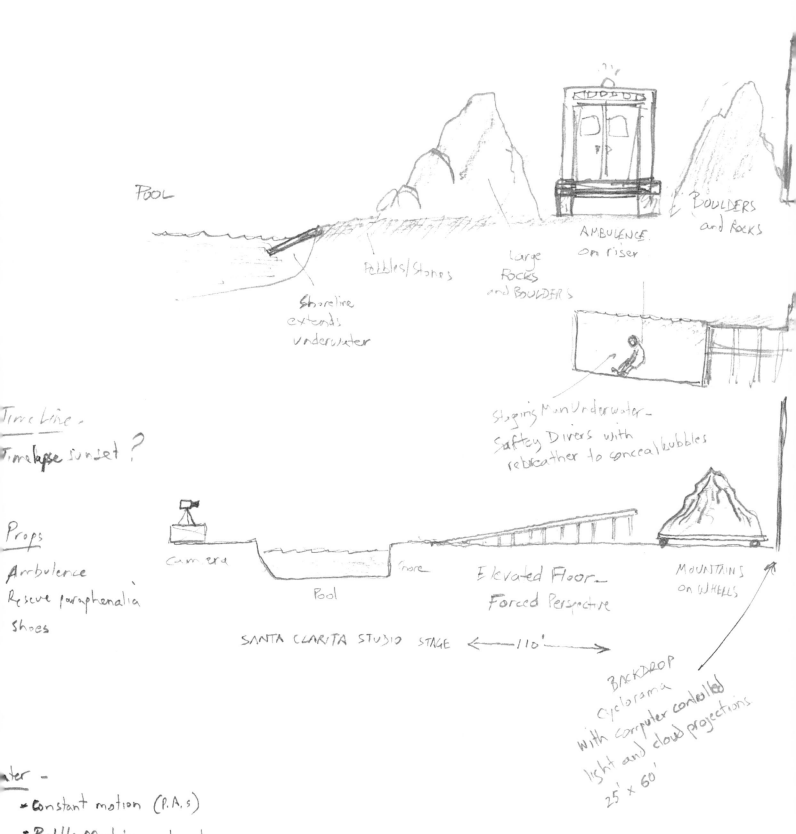

elight: Twilight (cool light)

POOL

Shoreline
extends
underwater

Pebbles/Stones

Large
Rocks
and BOULDERS

AMBULENCE
on riser

BOULDERS
and ROCKS

Staging Man Underwater -
Saftey Divers with
rebreather to conceal bubbles

Time Line -

Timelapse sunset?

Props

Ambulence
Rescue paraphenalia
Shoes

Camera

Pool

Shore

Elevated Floor -
Forced Perspective

MOUNTAINS
on WHEELS

SANTA CLARITA STUDIO STAGE ←——— 110' ———→

BACKDROP
cyclorama
with computer controlled
light and cloud projections
25' x 60'

ter -

• Constant motion (P.A.s)

• Bubble Machine - underwater

Sunrise

"The setting of the senses is the Dawn of Truth." Hein

The first light of dawn is a space of silent commun
Workers retract into their own world. Social interactio
gestural not verbal. External actions become introspe

The nocturnal world rece

Timeline — 30 MINUTES

The Space of Time — The Shape of Lig

MASTER TIMELINE

so

a .

mes

the light of day .

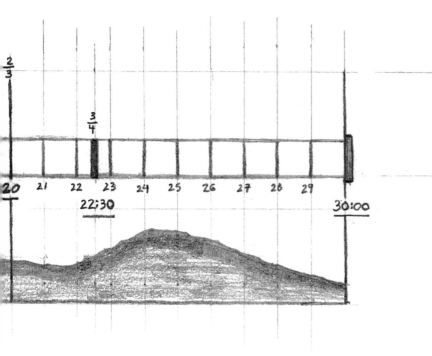

ANNIHILATION and ETERNAL LIFE

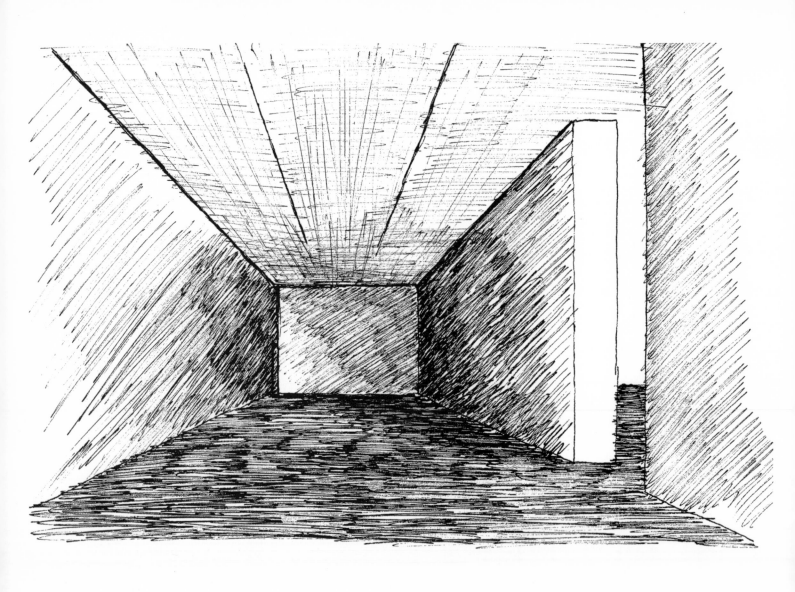

"Suffering is not overcome by leaving the pain behind. Suffering is overcome by bearing the pain for the sake of others."

The Dalai Lama